Working with

Copper, Silver and Enamel

Working with
Copper, Silver and Enamel

JAN AND OVE SJÖBERG

VNR VAN NOSTRAND REINHOLD COMPANY
New York Cincinnati Toronto London Melbourne

Cover photograph by Kenneth Jagger,
showing work in silver and enamelled copper
by Simon Gisborne.

Van Nostrand Reinhold Company Regional Offices:
New York Cincinnati Chicago Millbrae Dallas

Van Nostrand Reinhold Company International
Offices: London Toronto Melbourne

Originally published under the title
Gör vackra ting av koppar, silver, emalj,
by ICA förlaget, Västerås, Sweden
Copyright © Jan and Ove Sjöberg and ICA förlaget
English translation © Van Nostrand Reinhold
Company Ltd. 1974
Translated from Swedish by T. W. and E. Summers

Library of Congress Catalog Card Number 73-16713
ISBN 0 442 30034 4 cl.
ISBN 0 442 30035 2 pb.

This book is set in Univers and is printed
in Great Britain by Jolly & Barber Ltd., Rugby,
and bound by Henry Brooks, Cowley, Oxford

Published by Van Nostrand Reinhold Company, Inc.,
450 West 33rd Street, New York, N.Y. 10001, and
Van Nostrand Reinhold Company Ltd., Egginton
House, 25-28 Buckingham Gate, London SW1E 6LQ

16 15 14 13 12 11 10 9 8 7 6 5 4 3 2 1

Library of Congress Cataloging in Publication Data

Sjöberg, Jan
Working with copper, silver and enamel

(Reinhold craft paperbacks)
Translation of Gör vackra ting av koppar, silver,
emalj.
1. Art metal-work. 2. Jewelry making – Amateurs'
manuals. 3. Enamel and enamelling. I. Sjöberg,
Ove, joint author. II. Title.
TT2205.S5613 739 73–16713
ISBN 0–442–30034–4
ISBN 0–442–30035–2 (pbk.)

Contents

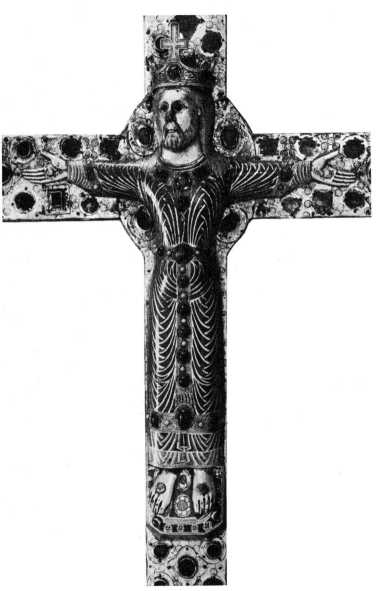

Altar crucifix with opaque champlevé enamel on gilded copper. Limoges-influenced, Swedish, end of 12th century. A fine example of historical enamelling.

Introduction

Decorative metalwork is a craft form that can be taken up without a large initial outlay on equipment; attractive jewellery, bowls, and other articles can be created even by the beginning craftsman.

This book is suitable for the beginner, since it describes all the basic processes involved, without assuming any prior knowledge. As progress is made it will become useful as a reference book, containing full details of the more advanced tools and processes. Those who already have some knowledge of basic metalwork will particularly welcome the sections on decoration and enamelling, and many of the objects shown in this book are specifically designed for decoration with enamels.

The authors are trained goldsmiths, and have taught metalwork extensively. They therefore have first-hand knowledge of making clear, concise explanations of technical processes.

Materials

Metals

The metals most frequently used by the craftsman are gold, silver, copper, gilding metal (tombac), brass, nickel silver and pewter. The choice depends on the object to be made and the craftsman's skill; for the beginner, the two which are soft, pliable and relatively cheap are pewter and copper. As his skill increases the craftsman may progress to silver and gold, particularly if he is making jewellery. The two designs for silver chains on p. 47 are simple and involve no soldering; it will therefore not be difficult for the beginner to make these successfully.

Metals fall into two categories according to their capacity to resist the effects of air and water. Those that remain unchanged are known as the precious metals, and those that are affected and do undergo change are called non-precious or base metals. When metals fuse with other metals, the result is an alloy: sterling silver, described below, is an alloy of silver.

Precious metals
Gold

Gold is the easiest of all metals to work. Since earliest times it has been a symbol of wealth, and used to be the principal metal for coinage. In Great Britain it is necessary to have a Bank of England licence to buy gold for manufacturing purposes, and it is illegal to hoard bullion. Pure (24 carat) gold is yellow, very soft, and melts at 1063°C. Gold can be hardened by being alloyed with electrolytic copper and pure silver, and 'red' gold and 'green' gold are produced by increasing the amounts of copper and silver respectively in the alloy. 'White' gold contains nickel. Gold is soldered with special gold solders, the melting point depending on their composition. A mixture of nitric and hydrochloric acids *(aqua regia)* will dissolve gold.

Silver

Fine silver is in the proportion of 999/1000

— in other words no fewer than 999 parts in 1000 must be pure silver — and it melts at 961.5°C. Sterling silver is 925/1000 and melts at 896°C. In Britain and the U.S. no article may be described as 'silver' if the proportion of silver is smaller than this. Pure silver is so soft that it is unsuitable for functional or decorative objects, which are better made from sterling silver, or Britannia silver. The most suitable shape for a silver object is bowl-like, and this is even more preferable if the article is to be enamelled, since enamel cracks rather easily. Neither hydrochloric acid nor *aqua regia* will dissolve silver, but a mixture of concentrated sulphuric acid and nitric acid will. Sterling silver indicates that it has been sufficiently annealed when the surface turns white with a touch of red. Silver is obtainable in sheet and wire form, in a variety of gauges.

Base metals
Copper

This metal has a characteristic red colour. As it combines both malleability and strength it is very suitable for objects that require shaping. Its melting point is 1083°C. When copper is being shaped, i.e. subjected to hammering, twisting, rolling, drawing etc., the worked parts harden and can easily crack. Annealing will eliminate this and should be carried out after each working process, the metal being heated until it glows a dull red. Then the object is quenched or left to cool in the open air on a heat-resistant base. Annealing forms a scale on the metal which can be removed by pickling the workpiece in 1 part concentrated sulphuric acid to 9 parts water. Remember always to add acid to water, never the other way round, and pour in the acid in a thin, steady stream. The object need not be immersed after each annealing. After hard soldering the copper object must be cleaned very carefully.

Gilding metal or tombac

This is a golden red alloy of copper and zinc, usually 85% copper and 15% zinc. When intended for enamelling, the proportions should be 90% copper and 10% zinc. Its melting point is 990°C. Because of its malleability, gilding metal is now used increasingly in costume jewellery. It lends

itself particularly well to large objects, but its composition renders enamelling harder than with pure copper, for it cannot undergo repeated firing.

Brass

This is a yellowish alloy of copper and zinc. Brass has been used since ancient times for both functional and ornamental purposes. In the crafts field it is suitable for candlesticks, wall brackets, paper knives, bowls, trays etc., but it is quite unsuitable for enamelling. The easiest brass alloy to handle has the proportions 67% copper: 33% zinc. Brass is available in various forms — as sheet, strips, round discs and tubes. It should always be cooled slowly after annealing.

Nickel silver

This is an alloy of copper, nickel and zinc, and should not be confused with silver. In ancient times brass objects were commonly coated with silver — a practice still observed. Argentan, alpax and paktong are some of the alloys used in the trade. The nickel content determines the whiteness of the alloy. For example, the silvery white alpax contains 18% nickel. The alloy most generally used for making paper knives, cream jugs, sugar bowls, spoons etc. contains 12% nickel; in the course of time these objects turn yellow. Alpax of superior quality contains 60% copper, 18% nickel and 22% zinc, with a melting point of 990°C. Nickel silver is hard to work; it is very malleable both when hot and cold. It needs to be heated to 600–700°C and then allowed to cool slowly. It is unsuitable for enamelling.

Tin

Tin is a soft and malleable metal. Objects requiring great heat cannot be made from it since it cannot be annealed — its melting point is 232°C.

Pewter

Pewter is made by adding to tin a low percentage of antimony or copper providing increased hardness and durability. Pewter can be annealed by immersion in boiling water. The wide range of objects suited to pewter includes bowls, platters, sugar sifters, bracelets, brooches and pendants.

Soldering materials

Soldering is the most common method of joining pieces of metal together. The surfaces to be joined must be perfectly clean; to prevent oxidation of these surfaces when they are heated, a flux is applied. Very small, thin strips of solder are laid along the joint with the appropriate flux, and the whole is heated to the required temperature to melt the solder. The common grades of silver solder are hard, medium, easy, and extra easy.

Flux

Each kind of commercial solder has its appropriate flux. Powdered borax can easily be prepared for extended silver soldering by mixing 2 parts potash, 2 parts cooking salt, and 1 part borax. Alternatively borax can be bought in cone form and ground in a shallow stoneware borax tray with a small quantity of water. Care must be taken when doing minor soldering jobs, since the borax mixture gives off bubbles when heated and these may dislodge the strips of solder.

Soft solder (lead/tin solder)

Soft solder melts at 200°C. It is used where durability is not of prime importance and where the metals to be soldered have a very low melting point. Soft solder is suitable for use with iron, copper, brass, nickel silver, pewter etc., and is generally easy to work with. If specially low melting points are required — such as for pewter — bismuth or cadmium are added to the solder.

A lead/tin solder paint called Fryolux can be purchased, suitable for both tinning and soldering. It should be brushed on to the surface of the object, which is then heated over a flame from the underside. The fusing temperature is about 220°C.

Hard solder

Hard solder is used where a stronger seam is required, and the various types have much higher melting points than soft solder.

1. **Brazing spelter** is composed of copper and zinc with no lead or tin, and comes in hard, medium, and soft grades. The hard one contains 60% copper and 40% zinc and melts at 900°C; the medium one 55% copper

and 45% zinc, melting point 880°C; and the soft one equal proportions of both metals, melting at 870°C. It is used on copper, and can be obtained in wire, powder or strip form.

2. **Silver solders** are alloys of silver, copper and zinc, and the various grades are as follows:

Grade	Melting point °C
Enamelling	800
Hard	775
Medium	765
Easy	725
Easy-flo (the only suitable hard solder for brass)	630

Silver solders are used for soldering copper, gilding metal, nickel silver, and brass, but they are not used on sterling silver because hall-marking requirements demand not less than 925 parts of pure silver in 1000.

The hardest of the silver solders has the highest silver content; the others contain increasing amounts of copper and zinc. A hard solder should be used for the first soldering job on an article, other soldering jobs being done with progressively softer solders.

In more advanced enamelling work, the enamelling is always left until last; therefore a very hard solder is required — one that will not melt during the firing of the enamel. An alloy of 6 g. pure silver and 1.5 g. electrolytic copper can be used for enamelling solder. The metals should be melted in a crucible, and the resulting alloy rolled into a thin sheet; the process should be repeated three times. It is advisable to label this solder in order to distinguish it from silver sheet.

3. **Sterling silver solders**: the various grades are as follows:

Width	Grade	Melting point °C (approx.)
2mm.	Enamelling	800
6mm.	Hard	750
2mm.	Medium	735
3mm.	Easy	715
3mm.	Extra easy	690

Tinning

Working with pure tin to cover copper objects can be very troublesome. For one thing, the slightest impurity on the copper prevents the tin from adhering; the surface has to be absolutely clean and free of grease and oxides. It will sometimes be necessary to clean the copper with nitric acid — take great care, and if necessary dilute the acid by pouring it carefully into water. The solution should be tried out first on a piece of iron. A quick dipping of the object should be sufficient for cleaning, after which it should be rinsed in water.

The clean metal is brushed with flux to inhibit oxidation. Tin is applied and the object gently heated until the solder melts. If a bowl is to be lined, the object is rotated to allow an even flow of the liquid. To assist even lining, steel wool can be used to spread the coating.

Chemicals

A variety of chemicals will be required for pickling, cleaning, etching, polishing, soldering etc. Pickling, which involves immersing the metal article in an acid solution, is a frequent operation and always follows annealing or soldering. The acid burns off the dark oxide layer formed by annealing, and the glass-like layer produced during soldering. Chemicals, particularly acids, should be kept clearly labelled and used with caution. A detailed list is given in the section on chemicals on p. 90.

Tools and basic techniques

Workshop

The ideal workshop, light and spacious, would offer separate working areas for each different job. Such conditions are beyond the reach of most people, and this section describes the basic requirements for anyone intending to set up a metal workshop.

The first essential is a bench with a good, solid, easy-to-clean work surface, such as laminated plastic. For evening work an adequate number of lamps are needed to eliminate shadows. Enamel work should be carried out by daylight as the matching of colours is of prime importance. The workshop must be kept as free from dust as possible — dust will easily penetrate and spoil enamel.

Another point to bear in mind is noise, and its amplification by the vibrations from the bench. The problem can be much reduced by using a heavy section of tree trunk into which stakes may be driven (see p. 39).

An alternative would be to hold a stake in a steel vice.

The height of the chair is important; it should be carefully adjusted to the best height for the workbench. It is usual to file large objects standing up — see that the jaws of the vice are at elbow level.

The bench pin is a wedge-shaped wooden piece which fits into its own slot on the workbench (see p. 13), and is a serviceable aid in filing small objects. One side forms an obtuse angle to the bench top, and serves as a support for small filing jobs. Reversed, it lies parallel to the bench top, becoming a base for sawing. A drawer or piece of leather under the bench pin will catch filings; this is important when working with precious metals. The amount of waste can be surprising — you can melt it down again if you have the facilities, or ask your supplier if he will exchange it for wire, sheet, or other materials. Metal waste can be swept up with a small, soft-bristle brush — traditionally a rabbit's foot.

Storage
All tools should either be kept in the workbench drawers or in a nearby cupboard. The

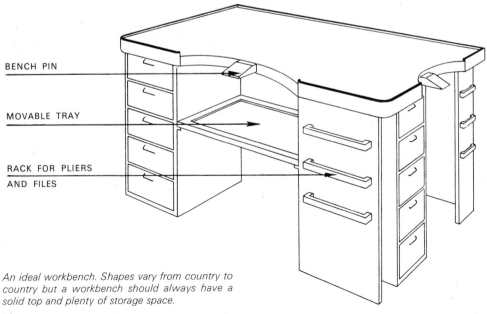

BENCH PIN

MOVABLE TRAY

RACK FOR PLIERS
AND FILES

An ideal workbench. Shapes vary from country to country but a workbench should always have a solid top and plenty of storage space.

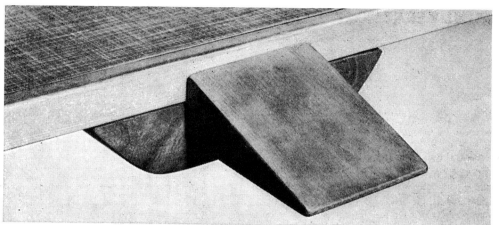

Bench pin. Above: ready for filing. Centre: ready for sawing.

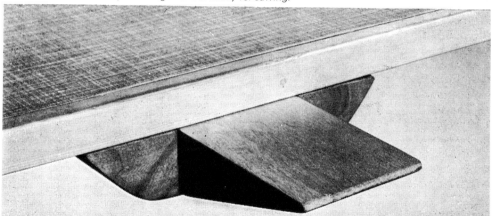

Below: slot for attaching the bench pin.

storage of chemicals is discussed in detail on p. 90, but it is worth mentioning that normal room temperature should not be exceeded or poisonous fumes may be produced. Running water must be available for general purposes, and in case of accidents when handling acids and other chemicals.

Buying and using tools

Basic tools
Anyone taking up metalwork or silversmithing will in the course of time acquire a number of tools. At the outset he will find the following are the most useful:

1. Ball pein hammer
2. Mallet
3. Half-round file, Swiss pattern, smooth, about 15 cm. (6 in.)
4. Hand file
5. Fine emery cloth
6. Steel wool
7. Silver polish
8. Polishing stick
9. Grinding wax — crocus polishing compound
10. Polishing wax — jewellers' rouge compound
11. Steel rule
12. Combined scribing and burnishing steel point
13. Spring dividers
14. Spring calipers
15. Glue — use an epoxy resin (e.g. Araldite)
16. Tweezers
17. Sawing board or bench pin
18. Flat pliers with smooth jaws
19. Bending pliers with smooth jaws
20. Side cutters
21. Jewellers' snips — 15 cm. (6 in.)
22. Piercing saw
23. Hand drill
24. Centre punch
25. Twist drill
26. Anvil
27. Vice
28. Soldering base, asbestos
29. Bunsen burner, butane gas container, two burners, blowtorch with burner

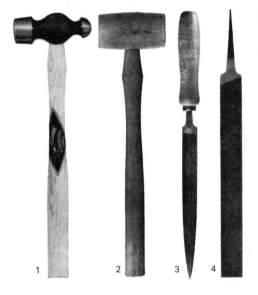

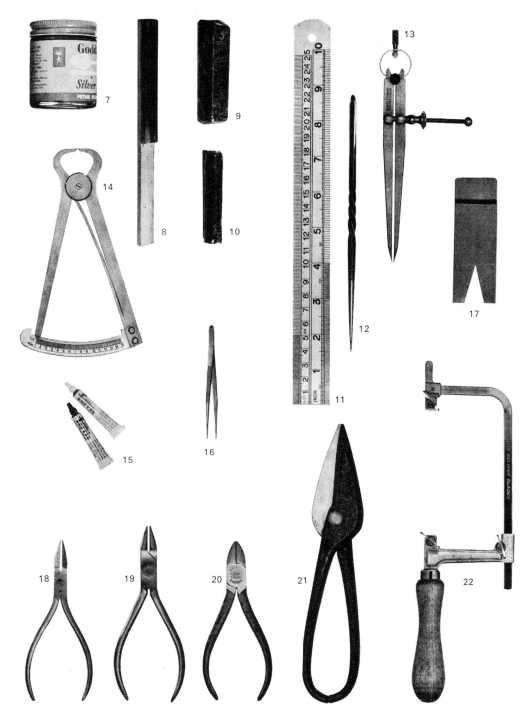

7

9

10

8

14

15

16

11

12

13

17

18

19

20

21

22

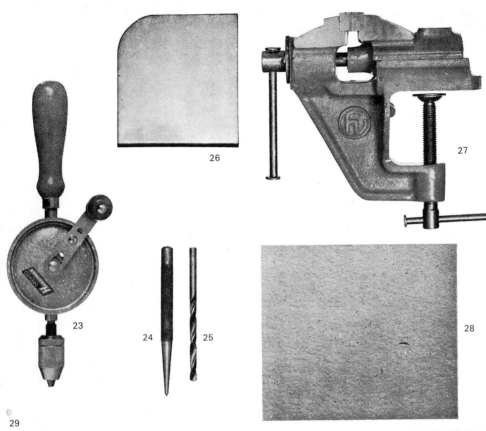

23

24 25

26

27

28

29

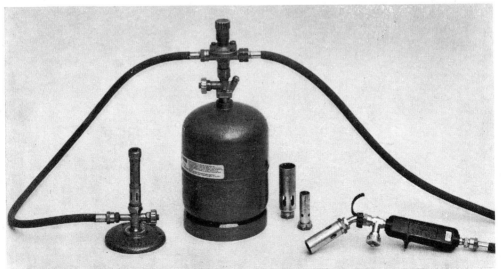

Special tools

This section deals with a further set of tools, those used by the professional. Purchase them if and when the need arises. The polished bossing and planishing hammer is among the most useful of the hammers illustrated here. As its name suggests, it is a dual-purpose hammer, and can be used for a number of operations. The double bossing hammer, because of its extended head, makes it easier to work on deep bowls. Another very useful tool is the small snips (no. 2, p. 18), used for cutting small strips. The parallel pliers provide a firmer grip than the ordinary flat-nosed pliers and can also be used for wire drawing. Shaping pliers can be made in the workshop. The screw clamp, illustrated on p. 19, has leather-covered jaws and will therefore grip without leaving marks.

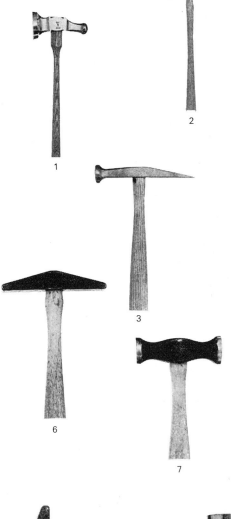

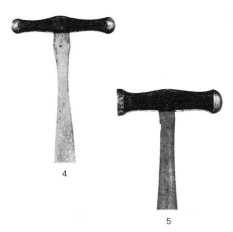

1. Chasing or repoussé hammer
2. Watchmakers' hammer
3. Combined creasing and general pur-
 pose hammer
4. Blocking hammer
5. Blocking and planishing hammer
6. Raising hammer (used for raising
 beaker shapes on a stake)
7. Planishing hammer
8. Forging hammer
9. Planishing hammer
10. Planishing hammer

17

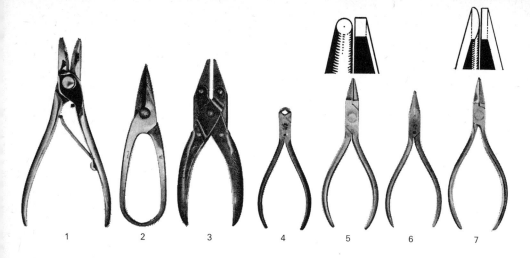

1. Shaping snips with curved jaws
2. Small snips
3. Parallel flat-nosed pliers
4. End cutter
5. Flat- and round-nosed pliers
6. Pointed-nose pliers
7. Flat- and round-nosed pliers

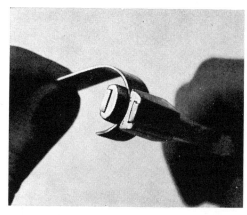

Three shaping pliers for plain, concave and convex shapes, The shaping parts of the pliers are brass — either forming a covering or soldered on to the jaws.

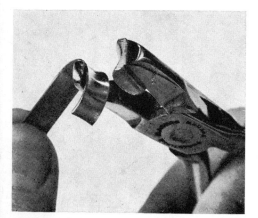

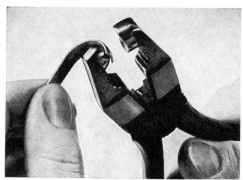

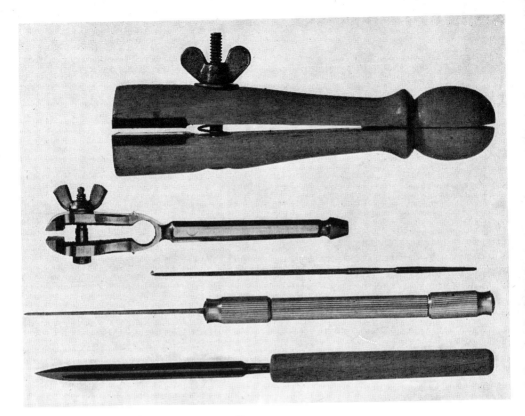

From the top: screw clamp, pin vice, scriber, scriber with handle, three-square scraper.

Files

Knowing the trade terms is a help in buying files. Length refers only to the part which does the work — not including, therefore,

Files — from the left: double cut, single cut and rasp.

the tang. The name applied to the file can refer to its shape, i.e. round or half-round, or may suggest its use, i.e. saw file or warding file. Grades are listed as coarse, bastard, second cut, smooth, and dead smooth; however the cut of a smooth file can vary with its length (i.e. the smaller the file, the finer will be its cut).

Handles

Files are sold without handles, which must be fitted before the file can be used. Wood or plastic are both suitable for handles. To fit a wooden handle, the bore hole may require enlarging: heat an old file and insert it into the bore hole of the new handle. When this

19

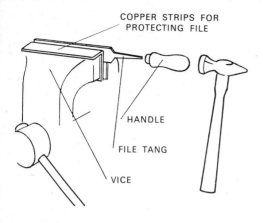

COPPER STRIPS FOR
PROTECTING FILE

HANDLE

FILE TANG

VICE

This is how the handle is fixed to the file. The vice jaws are covered to protect the file teeth.

hole is the correct size, the new file can be fitted into it. With the end of the file in the protected jaws of the vice, the handle is driven in by applying a few light taps with a hammer, taking care not to split the handle.

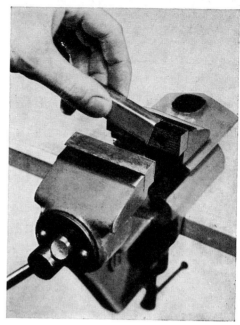

Protective coverings for vice jaws.

Diagonal filing is done with long, even strokes all along the edge of the strip.

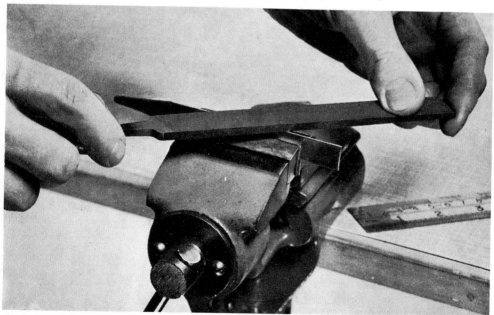

Filing

To avoid vibration when filing, the object should be clamped tightly in the vice and held fairly low. Speed and pressure should be adjusted to the hardness of the object. With a new file, pressure should always be light to prevent excessive damage to the file teeth. You will need to increase the pressure as the file gets older. As a general rule all files cut only on the forward stroke, and should be lifted on the return stroke, thus avoiding premature wear.

Protective coverings

In order to avoid scratches and other marks on the object when it is clamped in the vice for filing, some kind of protective covering is necessary. This should always be of a softer material than the object being worked, and fibre vice-guards are available in a variety of sizes to fit the particular vice. It is also possible to make your own covering from fibre, or two lengths of beech wood. When buying the covering, make sure sufficient allowance is made for the width of the vice.

Diagonal filing

When a strip of metal with parallel edges is required for making, say, a bangle, you should check the straightness with a steel rule or set-square. Should the edges be out of parallel and not fit exactly, a fresh line must be scribed. The metal strip is clamped in the vice, and filed down to the new mark. File diagonally in long, even strokes over the full length of the metal strip to provide a perfectly even edge. To remove a large amount of metal a coarser file must be used.

Draw filing

After the metal edge has been diagonally filed, it will need to be draw filed to produce a smoother finish. Use the file to and fro lengthwise along the edge of the object. This will produce filing scratches alongside the edge, but these can be removed by rubbing with emery cloth. A single-cut file is the best type to use for draw filing, although other types can be used if necessary.

Filing shaped edges

If the object has a curved or shaped edge, a half-round or crossing file is required. Throughout this operation, the filing should combine a forward push with a sideways rocking movement. File with strokes as long

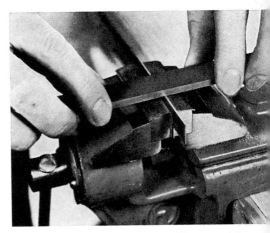

A single-cut file is used for draw filing a straight edge.

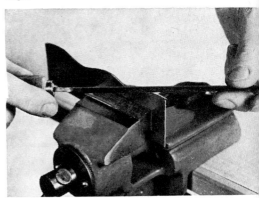

For shaped edges, a half-round file is used. Below: draw filing a shaped edge.

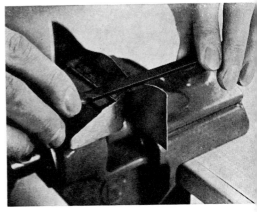

as the shape permits, diagonally along the edge. The work can now be finished off using a draw file of a finer gauge than that used on parallel-edged metal.

Needle files

Needle files for fine work are manufactured in various sizes and gradings. Twelve shapes of needle file are available, in sizes varying from 12 cm. (about 5 in.) to 18 cm. (about 7 in.) long. The cuts are 0, 2, 4 and 6 – from coarse to fine. These files do not require handles as they are incorporated in their shape.

Another type of file for fine work, though physically larger, is the Swiss Precision file which comes in lengths of 4 in., 6 in. and 8 in. (about 10 cm., 15 cm. and 20 cm.

Handle with two-jaw chuck of synthetic resin for needle files.

A selection of needle files and their sections.

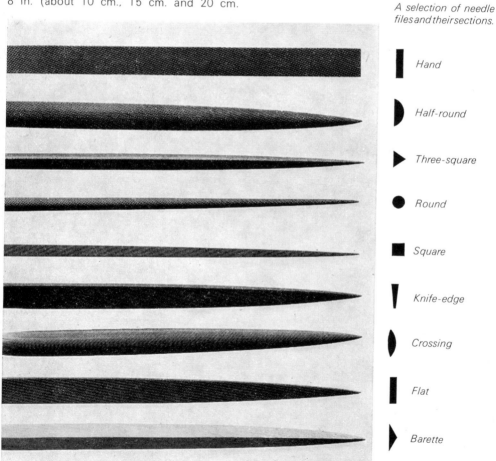

Hand

Half-round

Three-square

Round

Square

Knife-edge

Crossing

Flat

Barette

Cleaning a file with a piece of hard wood or a strip of copper, moved along the file at an angle in the same direction as the teeth.

respectively). There are many shapes (similar to needle files) and they are graded 00, 0, 1, 2, 4 and 6 from coarse to fine. These files require properly fitted handles as they are made with tangs.

Cleaning files

In the course of any lengthy work, files will need to be cleaned now and again. For this purpose a special brush of fine steel wire should be used. File teeth can also be cleaned by drawing a piece of soft metal, i.e. copper or brass, at an angle along the file in the same direction as the inclination of the teeth; even a piece of hard wood can be used for this. Immerse the file in boiling water for a short time before cleaning.

Polishing with emery cloth

After the final filing, the polishing process begins, starting with a medium emery cloth, gradually progressing through a range of finer grades, and completing the job with emery sticks. Emery cloth and emery paper are often more effective if they are first glued on to pieces of wood to make emery sticks.

Emery sticks of various widths and gradings. Rectangular sticks graded 3, 2, 1, 0 and 00 from coarse to finest, can be bought from jewellers' suppliers.

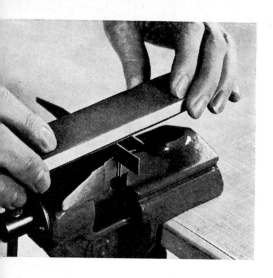

A strip of metal intended for chenier being polished lengthwise with an emery stick.

Putty sticks

Small objects are often difficult to hold when filing and drilling, and a simple tool can be made from a wooden stick, to one end of which a lump of special putty has been applied. The object being worked is placed in the putty, the whole is gently heated, and then left to cool. When the putty hardens, it provides a firm grip on the object, which is then under pressure while being worked on. When the work is finished, the tip of this tool is heated over a gas flame, and the object can then be separated from the putty quite easily with pincers. The wooden stick should be held carefully so that putty does not drip on to the workbench. A range of sizes of putty sticks will be required, from very narrow pencil-size to relatively large ones. The ingredients of the putty mixture are 125 g. resin or shellac, 100 g. chalk, 25 g. gypsum, plus some beeswax. Mix the ingredients in an old pan and stir with a wooden stick. The chalk and gypsum must be in fine powder form to avoid lumps in the mixture.

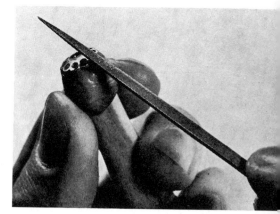

Small objects are easier to work if they are fixed on to a shellac stick (lapidaries' dopping wax is a suitable medium).

Surface treatment

Metal colouring (oxidation)

This treatment belongs to the finishing stage and can be defined as changing the surface colour of the metal by chemical means. The usual term is 'oxidation', which strictly speaking is misleading, since the term really means a change brought about by the oxygen in the air. When, for example, an embellishment is made to copper or silver in the form of black colouring, sulphur is added to form copper sulphide, which, like the oxide, is black. It is possible that since both these chemical processes cause the metal to turn black, the term 'oxidation' came to be used in both contexts.

Much experience and a sure eye are required to obtain successful results from controlled oxidation. The first essential is that the metal surface must be thoroughly clean. The following procedure is recommended.
1. Immersion and rinsing in clean water.
2. Scraping and possibly applying a paste of Vienna lime and water. This is essential where highly polished surfaces are being worked. A semi-polished metal surface can be obtained by scrubbing with powdered pumice stone which has been mixed with water into a paste. This treatment will produce a clean surface free of grease.
3. To make absolutely sure, the object can be tested in clean, cold water. The object is ready for colouring if the entire surface is coated with water, indicating that no grease is present.

Silver – black

The following mixture should be applied, cold:
 25 g. liver of sulphur
 10 g. ammonium carbonate
1000 g. water

This mixture is either brushed on to the object, or the object can be immersed in the pickle until the desired colour is visible. The object should then be rinsed in clean water. Should weaker oxidation be required over part of the surface, rub that part with powdered pumice stone after oxidation, until the desired tone emerges. Finally, after a light polishing, the object is washed in tepid water containing a synthetic washing powder and a few drops of ammonia.

Copper – brown to black

 15–20 g. liver of sulphur
 2–3 g. ammonium chloride
 1000 g. water

Brass – black

 100 g. copper carbonate
 1000 g. ammonia
100–150 g. water

After colouring, copper and brass must be treated and cleaned in the same way as silver.

Pewter – grey

10 g. iron chloride
90 g. water

The object should be immersed for a few minutes, rinsed in cold water, and dried. For toning down the colour, steel wool grade 000 can be used, or pumice stone 6/0. For final polishing, any of the common metal cleaning polishes can be used.

Polishing by hand

A special polishing steel and agate burnishing stones are widely used for polishing silver and gold objects. The steel or stone is dipped in water to which washing powder has been added, and then moved backwards and forwards over the surface to be polished. At intervals, the steel and the stone themselves need polishing to retain their effectiveness.

Polishing sticks

The edge of a piece of jewellery should be polished by hand using two felt sticks – one of these should have crocus composition applied to it, and the other should be smeared with jewellers' rouge. The napped side of a piece of leather can also be used in the same way after being waxed. The wax layer on the felt and the leather hardens when it has been used for some time, and becomes less effective, but any sharp object will help to put this right.

Method:
1. Apply grinding wax to one felt stick.
2. Burnish object.
3. After initial polishing, wipe or wash the metal surface to avoid transfer of wax to the other polishing stick.
4. Polish with second stick, using jewellers' rouge.

Above: using a burnishing steel.
Below: using a felt polishing stick.

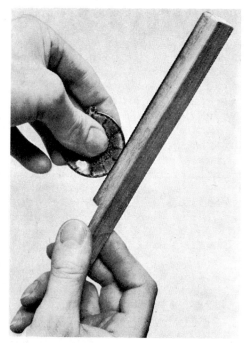

Soldering

Hints for soft soldering

Soft soldering can be used on most metals. Sometimes, however, a soldering iron is preferable to a gas flame, because the stronger gas flame may damage surrounding precious or brittle parts of the object, such as stones, glass, wood etc. Soldering irons are useful where the job is not too large, and particularly useful on small pewter jobs (using tallow, or paste flux). The iron has a copper bit which is heated and coated at the tip with solder, and then applied to the joint.

Soft solder is preferable if you want to retain the springiness of a metal; hard solder is inappropriate in this instance, unless work-hardening is possible.

When soldering a support to a copper bowl made of, say, 1 mm. thick sheet, a gas flame is more suitable for soft soldering due to the high conductivity of copper, causing great heat loss. If the metal is overheated, it will get too soft and readily develop bulges when handled.

The special solder for pewter is called LMP solder, and melts at about 150°C. It is composed of lead, tin, and bismuth. This solder is particularly useful for repairing and soldering pewter brooches and brooch catches.

Blowtorches

These can be used with town gas or natural gas, and when you purchase one you should specify what type of gas you will be using. On the type of blowtorch illustrated, the size of the flame can easily be adjusted by turning a control knob. The heat intensity increases with increased air supply, which can be controlled through the mouthpiece. The gas inlet tube must be attached to a gas cooker or other source of gas supply. Should piped gas be unavailable, gas from cylinders (e.g. butane, Calorgas) will be just as effective (see p. 16). Make sure your blowtorch is right for this kind of gas.

Preparation

The surface of the area for soldering should be filed, and then polished with emery paper. The join should fit perfectly, the two ends

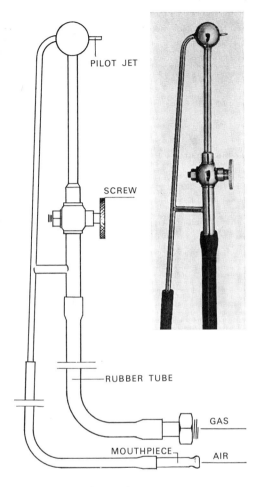

PILOT JET

SCREW

RUBBER TUBE

GAS

MOUTHPIECE

AIR

French pattern blowtorch.

Solder

Solder should be applied to the join in such a manner that any excess can easily be filed off. The amount of solder will of course depend on the nature of the join. Small pieces of solder are put on with a fine paintbrush: the brush is first dipped in flux, then the pieces are picked up and carefully positioned. More details of solders and fluxes are given on pp. 10–11.

Joining

The area to be soldered should be heated with a gas flame. Larger objects require a

Above: rotating soldering top, and asbestos square on tripod.
Below: piece of asbestos, solder, and asbestos square on heat-resistant base.

being as near exact replicas of each other as possible. In a well-fitted join solder grips all the more tenaciously for being sucked in equally through both ends (capillary attraction).

Flux (barrier against oxidation)

Flux should always be painted on right round the whole surface involved in the join. Powder borax flux is mixed with clean water to produce a smooth paste for hard soldering, and proprietary brands suitable for soft soldering are readily available.

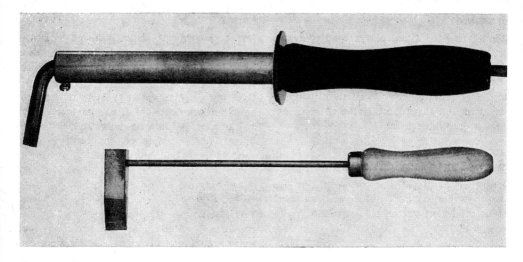

Electric soldering iron, and soldering iron for heating with gas

hotter flame, the size and heat of the flame always being adjusted to the object and its material. Heat must be evenly applied so that the rise in temperature occurs simultaneously on both sides of the join. The solder will then flow equally into each side of the join. Remove the heat immediately the solder has melted and fusion is complete. The object should now be left to cool.

Pickling

After oxidation any dark layer left must be thoroughly cleaned off. A suitable pickling mixture consists of 1 part sulphuric acid to 9 parts water. The pickling process can be slightly speeded up if gentle heat is applied to the acid in a copper boiling pan. When pickling silver objects, they should not be handled with iron tweezers, since iron causes silver to discolour. After pickling, both object and tweezers should be rinsed in clean water.

Brushing

A matt layer is generally left after pickling: polishing with a brass brush will remove this. Do not, however, use a brass brush on silver.

Separate tools for soldering

The tools that normally come in contact with objects during soldering suffer damage from numerous heatings; ideally an extra set of these tools should be kept, and their use confined to soldering. They will most frequently be clamps of various kinds, which can easily be made in the workshop. Suitable materials for them would be stainless steel, nickel silver, piano wire, flat wire etc. Piano wire is easy to cut, file, and shape as required. When metal has been worked for some time, it tends to become hard and unyielding. This is known as 'work-hardening'. The workability of most metals can be restored by annealing. This involves heating to a temperature which varies from metal to metal — see the section on metals on p.9 for further information. Heating is followed by cooling to room temperature. Metals should always be pickled after annealing.

A selection of clamps.

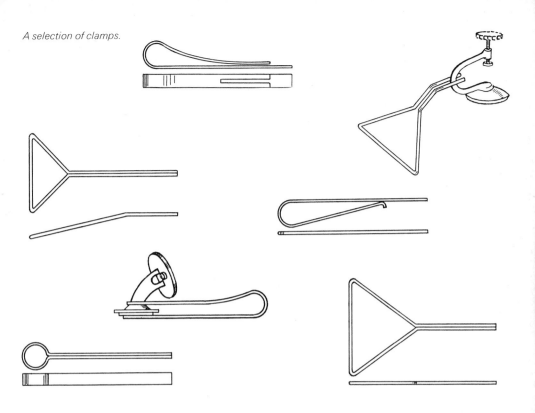

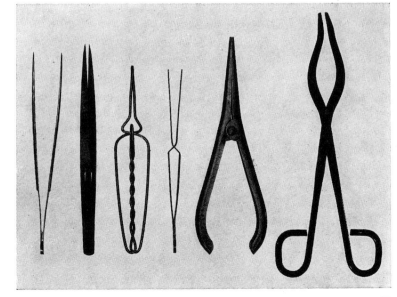

From left to right:
Tweezers
Tweezers with
 adjustable spring
Soldering clamp,
 steel wire
Soldering clamp,
 stainless steel
Soldering tongs
Crucible tongs

Some technical tips

This section deals with a few practical details that apply to a wide range of jewellery making, and frequently give rise to problems.

Paper patterns

Before cutting out the metal it is usual to make a paper pattern and fix this to the metal. Scribe round the pattern before cutting. The metal is supported on the bench pin, and the shape cut out with a piercing saw. If sawing becomes difficult, the blade of the piercing saw should be daubed with a little beeswax. For thin metal use a pair of round-nosed plate shears, holding them so that you do not conceal the scribe marks.

Hollowing

To provide a piece of jewellery with some variety, the whole piece or part of it can be hollowed. A file handle may come in useful (see illus. p. 22 top). The object is placed on a gouged wooden former, which is itself

Using a paper pattern which has been glued to the metal from which the basic shape is to be cut. Sodium silicate (waterglass) left to harden is a suitable adhesive, though it takes longer to dry than fish glue.

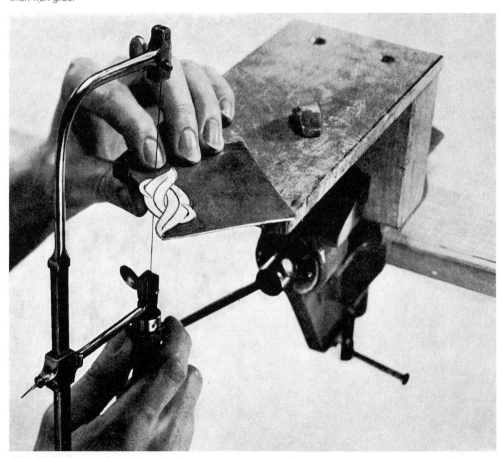

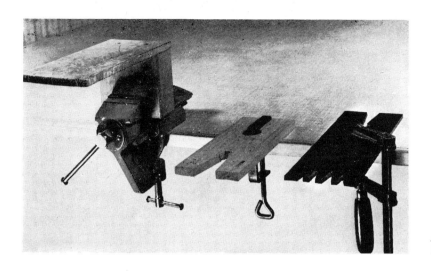

A selection of bench pins.

clamped in the vice. With the file handle on top of the object, tapping lightly with a hammer will produce the desired result.

Hammered edges

A hammered edge will add to the firmness of the object — a desirable quality in any case and even more so if the object is to be enamelled. The edge can be tapped while the object is supported on a piece of wood clamped in the vice.

Drilling

When making pendants, it is usually neces-

A file handle is used for shaping the piece of metal.

The edge is tapped against a round stake.

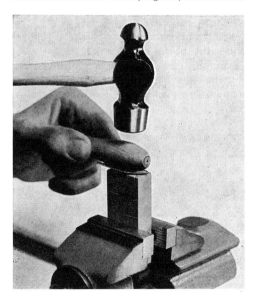

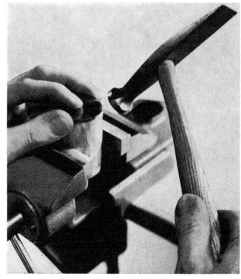

sary to drill a hole for the chain. Using a punch, mark the spot with a light hammer blow. On no account should a planishing hammer be used for this purpose — the impression of the punch would ruin its smooth surface. Support the object on a wooden block with a sound-deadening (rubberized) base; hold the object tight against the wooden block with a vice, and it is ready for drilling.

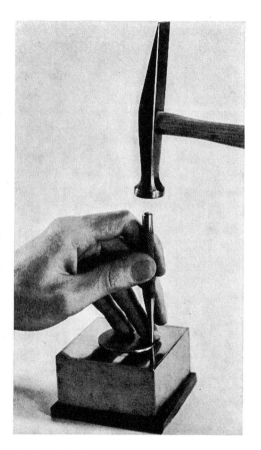

Marking the hole with a centre punch.

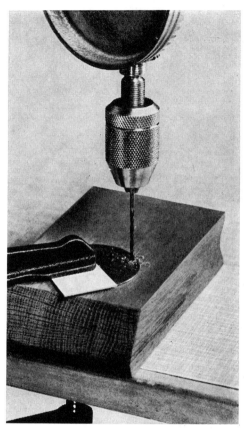

Drilling a hole. A piece of cardboard is used to prevent the object from being marked.

Making metal objects

From sketch to working drawing

A craftsman prepares for his work by drawing sketches or making models in paper, card or clay. The object should first be sketched full size, and coloured if it is to be enamelled. When the sketch is ready, a working drawing is prepared. For large pieces, details such as name of object, scale, material etc. should be given.

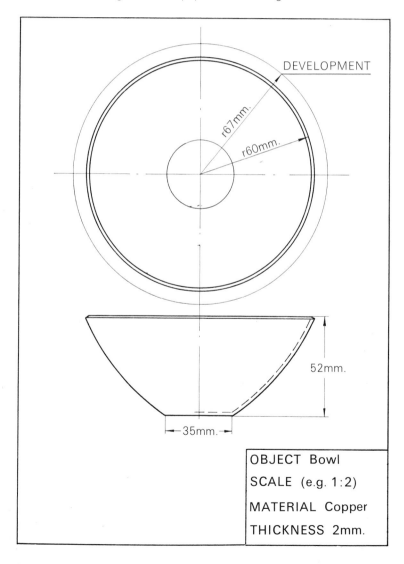

DEVELOPMENT

r67mm.

r60mm.

52mm.

35mm.

OBJECT Bowl

SCALE (e.g. 1:2)

MATERIAL Copper

THICKNESS 2mm.

Some basic shapes obtainable by using formers.

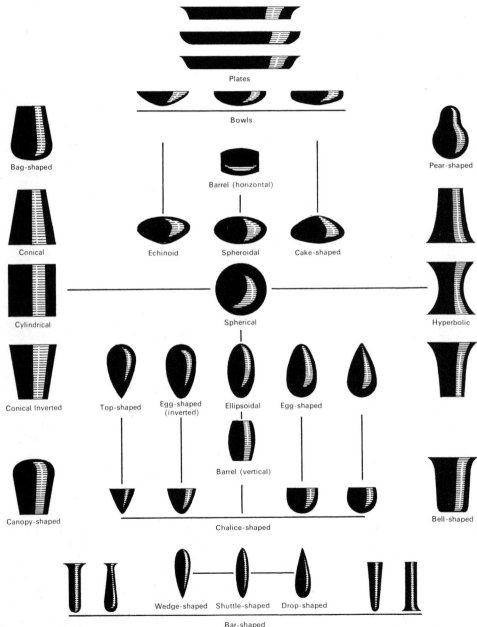

Plates

Bowls

Bag-shaped

Barrel (horizontal)

Pear-shaped

Conical

Echinoid Spheroidal Cake-shaped

Conical

Cylindrical

Spherical

Hyperbolic

Conical Inverted

Top-shaped Egg-shaped Ellipsoidal Egg-shaped
 (inverted)

Bell-shaped

Canopy-shaped

Barrel (vertical)

Chalice-shaped

Wedge-shaped Shuttle-shaped Drop-shaped

Bar-shaped

Wooden formers

To achieve the desired shape when working metals, blocks of hard wood are used as formers — these formers also prevent unnecessary marks being made on the object itself. They cannot be purchased ready-made, and have to be made by the individual craftsman to suit his own designs. The best wood to use is beech; ash and birch are also good, but beware of oak which has a tendency to crumble.

The metal is supported by the wooden former while being shaped with the blocking hammer. It is essential that the hammer face is both clean and smooth. With the sole exception of tin, the metal must be annealed before any work is done on it. The shape of each former clearly depends on the object to be produced. As an example, the size and

Using the blocking hammer, a silver strip is shaped against a wooden former into a convex bangle.

Wooden formers to assist in shaping metal objects. These are made in the workshop.

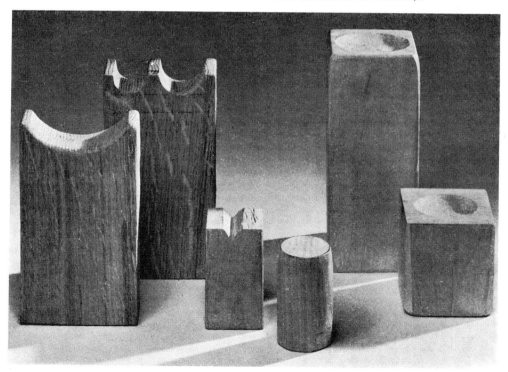

shape of a former for making bangles could be as follows: 14 cm. wide, 3 cm. thick, 10 cm. high (5½ in. × 1¼ in. × 4 in. respectively); the diameter of the hollow 8 cm. (about 3 in.), with maximum depth of the hollow 4 cm. (about 1½ in.).

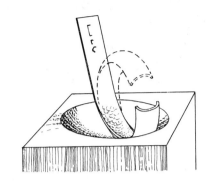

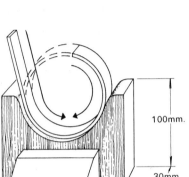
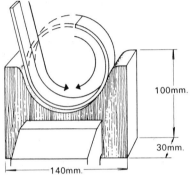

Above, and left: formers for shaping cylindrical and convex bangles.

Below left: tools required for making formers. Surform file, rasp, and two gouges. For deeper hollows, use a swan-necked gauge.

Below right: tapered bar for shaping bangles. The iron block provides an extra hard base to work on.

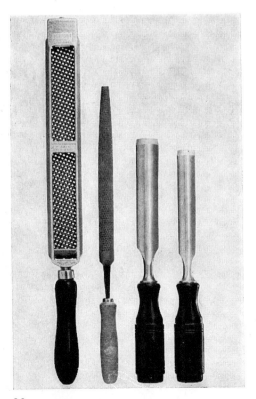

Making a bowl

Metal

Silver or copper are the most suitable metals for making bowls; tin, nickel silver and brass are less malleable. The thickness of the metal is of course determined by the type of bowl you have in mind. The following measurements can be taken as a guide:

Metal	Metal thickness
copper	1.5–3 mm.
sterling silver	1.25 mm.
pewter	1.5 mm.
nickel silver 12–18%	1.25 mm.
brass	1.5 mm.

The pieces of metal must be cut larger than the desired size of the finished bowl, the exact amount depending on the depth of the bowl, thickness of the metal and its degree of hardness. A further factor to consider is the metal's malleability.

Flattening the metal

Before work starts, the piece of metal must be made perfectly flat. This is done by tapping it with a wooden mallet against a hard piece of wood or a bench pin. Smaller strips of metal can be straightened with flat-nosed pliers.

Shaping the bowl

The metal is beaten down into the former with a blocking hammer. When handling a thin or soft metal, a bossing mallet or rubber-headed hammer is better.

Stages in making a round bowl

1. Draw a circle on the metal with a pair of dividers (the diameter of the bowl plus a little extra for expansion). Cut thin sheet with snips; for thicker metal, one handle of a pair of large hand shears could be held in the vice with a tubular extension handle; a piercing saw can also be used.
2. Cut out a square, then an octagon. Now it is easier to shape a circle.
3. Smooth the edge with a file.
4. Anneal the metal, and allow to cool.
5. Place the metal in a former, with the marks from the dividers downwards.

When cutting, it is important that the snips are so turned that they do not obscure the scribed line – this will depend on which way round the jaws are made.

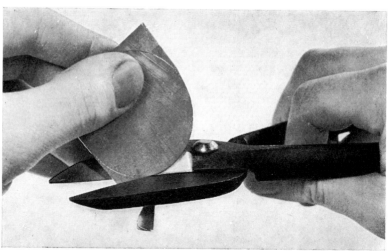

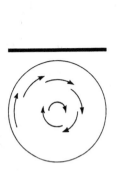 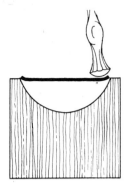 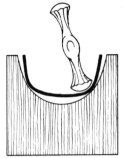 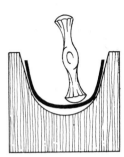

The drawings show how a bowl is shaped in a wooden former.

6. Shape the metal with a blocking hammer or bossing mallet.
7. When the metal starts to feel springy and hard, annealing is required. The object must be annealed frequently during this process to avoid cracking.
8. When the bowl has reached the desired size, it should be annealed again and left to cool.
9. Pickle the bowl to remove the dark-coloured oxide.
10. Rinse the bowl in water and dry thoroughly. No work should ever be carried out on wet metal.

Small enamelled bowls of 2 mm. electrolytic copper.

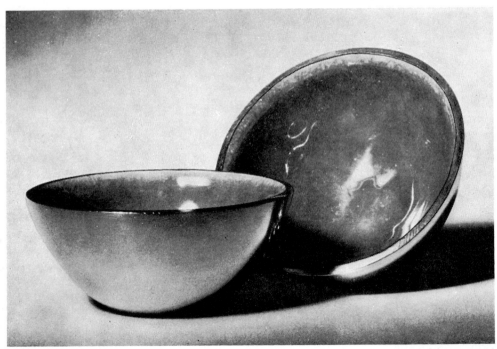

11. Polish surfaces with fine steel wool.

12. Beat with a mallet on a suitably-sized stake, which must be highly polished and free from any bumps if the bowl is to be perfectly smooth inside.

13. The outside of the bowl may still appear uneven, an effect which may well appear decorative, in which case the work only needs to be planished with a planishing hammer of a type and weight suitable to the job.

14. However, if the finished bowl is to be smooth both inside and outside, it must be hammered on the stake with the planishing hammer. The blows should be close together and even, starting from the centre and working in a spiral outwards. The individual marks of the blows will be seen on the inside and outside, the metal surface being quite smooth if the blows have been made evenly.

15. The edge of the bowl should be smoothed with emery cloth no. 1 or $1\frac{1}{2}$. Place the emery cloth on a flat surface, turn the bowl upside down, and press it against the cloth using a circular motion.

16. Mark lightly on the outside, with a pair of dividers, the centre of the bowl.

17. Clamp a piece of rounded wood in the vice, the diameter of the rounded section being slightly smaller than the bottom of the bowl. Place the bowl on top of this former, and shape the bottom of the bowl with the rounded end of the planishing hammer. Give the bottom a slight reverse hollow if desired.

18. File the rim of the bowl so that it slants outwards, almost at right-angles to the side of the bowl. Polish the edge with emery cloth.

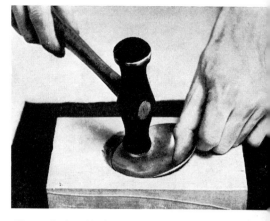

Above: the bowl is shaped in a former.

Below: the metal is made smooth by hammering it against a stake.

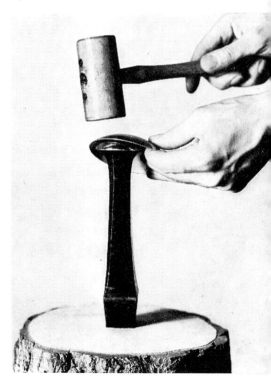

Filing the rim of the bowl.

19. If required, grind carefully with emery cloth to remove any unevennesses. Follow this by final polishing on a machine. Finally, wash the bowl to remove any traces of grease.

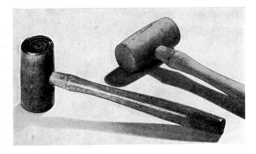

Above: mallets. The one on the left is made of rolled rawhide.

Below: shaping the bottom of a bowl.

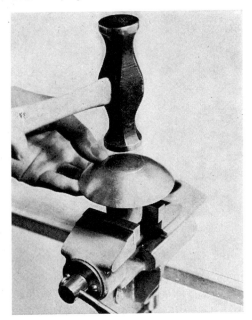

Tubes and hinges (chenier)

The term chenier covers two meanings in this book. In one sense it refers to a metal tube, to be cut up for use in a variety of purposes. Making this tube is known as 'drawing chenier' (opposite, above right). As an example of its use, certain chains have links of chenier.

However 'chenier' is also used to refer to the hollowed parts of a hinge (see opposite, below) — as in the hinge of a clasp, a lid etc. The hollowed parts of the hinge are made from chenier tube — hence the natural extension of the word's meaning.

Drawing chenier
1. Cut out a metal strip with parallel edges.
2. Shape the first 3 cm. (about $1\frac{1}{4}$ in.) of one end to form a wedge shape.
3. With a small creasing hammer, hammer the strip into a groove already prepared in a piece of hard wood, thus converting the strip into a long, open tube.
4. Close the tapered end completely; gently tap together the rest into the shape of a closed tube. Ensure the seam is straight.
5. Anneal this chenier, and leave to cool. The metal is now softer and ready for the next stage.
6. Clamp the draw plate in the vice.
7. Lubricate the chenier with beeswax before drawing. When wire is being pulled through a draw plate, it too should be waxed.
8. Check that this rough chenier is both even and straight. Place the wedge-shaped end in a suitable hole in the draw plate, grip with a pair of parallel pliers, and pull. Repeat the process through smaller and smaller holes till the required chenier diameter is reached.
9. Anneal the chenier and leave to cool.
10. Draw the chenier once more through the last hole. Now it should be absolutely straight.
11. If the seam does not require soldering immediately, scribe with a needle file across the seam, in short strokes. This indicates the seam position, so that the chenier, if used for hinge construction, can be placed in such a position that the seam is soldered at the same time as the tube.

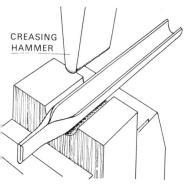

CREASING
HAMMER

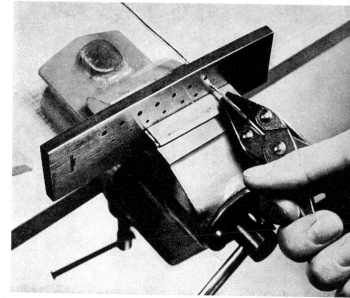

Above: the metal strip is shaped
by hammering it into a groove
made in a piece of wood.

Right: draw plate.

Below: making chenier. After tapering one end of
the metal strip, the rest is hammered into the shape
of a closed tube, ready to be drawn through a
draw plate. Note the small markings across the
seam for future reference.

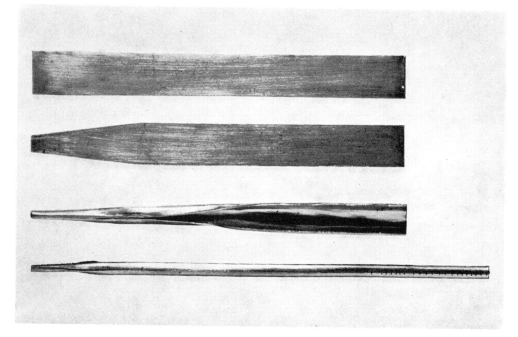

Measuring for chenier

To calculate the width of the metal strip required for chenier, multiply the required diameter of the chenier by 3.14 (π – the ratio of the circumference of a circle to its diameter), to find the circumference of the tube around the centre line of the metal. To this must be added twice the thickness of the metal to bring it to the correct size. In making chenier it is better, if in doubt, to err on the large side, for it is easy to draw down to the required size.

Making a chain

To make a chain you will require the following: a drill, bars, two pairs of flat pliers, a piercing saw and blades, a vice, steel wool, and cleaning materials. When attempting more intricate chains, certain measurements need to be borne in mind. In particular this applies to the kind of wire to be selected, and to the diameter of the bar, which is the tool

Jig with a grooved piece of wood, used for spiralling.

round which the wire is bound to form a spiral. The flexibility of the material is very important: the harder the wire, the larger will be the minimum circumference you can form with the loops. Wire for chains must be annealed first.

Turn a few loops, saw them apart by cutting along the length of the spiral, and couple these loops together. This experimental length will show you whether the links are the right size for the projected chain. Join the ends of each loop carefully, so that the overall appearance of the chain is not spoilt.

Calculating dimensions and weights

The two chains described in this book need not be soldered, although this can be done if desired.

The tables apply to chains made with round sterling silver wire. When using other metals, these measurements must be altered to suit the hardness of each particular metal. The upper part of the table gives details for a chain with three pairs of links; the lower part for a chain with two pairs (see illus. on p. 47).

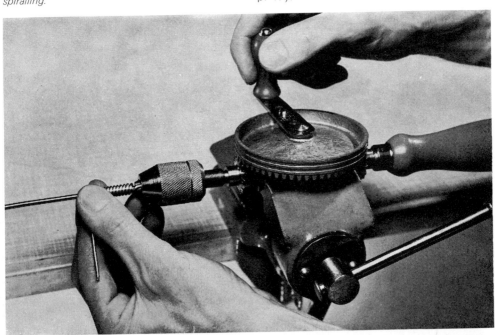

Sterling silver wire (round)	Bar (round)	Weight (approx.)	Length of wire for bracelet (approx.)
0.8 mm. 1.0 mm. 1.25 mm. 1.5 mm. 2.0 mm.	3.0 mm. 3.5 mm. 4.5 mm. 5.0 mm. 7.0 mm.	40 g. 45 g. 50 g. 55 g. 90 g.	3 m. (about 9 ft. 9 in.)
1.0 mm.	4.0 mm.	40 g.	3 m. (about 9 ft. 9 in.)

Stages in making a chain

Using a draw plate

So that the wire can pass more easily through the draw plate, one end of it should be filed to a shallow taper about 3 cm. (1¼ in.) long, which can then be passed through one of the holes. The draw plate is held in the vice, and the wire, gripped in a pair of parallel pliers, is pulled through the hole. For several size reductions, the wire may need re-annealing.

Annealing the wire

The wire should be annealed thoroughly. If you have to draw several metres of wire it must be wound into a tight ring so as to avoid burning the thin section.

Pickling

You can, if you like, remove the oxide by pickling.

Straightening the wire

At the same time as straightening the wire you can polish it with a fine emery cloth, or steel wool grade 000.

Making a spiral

The bar (see table on left) and the silver wire should be gripped in the chuck of a hand-drill, which should in turn be carefully clamped into a vice. In preparing the wire you should file the first 1 cm. (about ½ in.) and flatten the resulting surface. If you turn the drill evenly a regular spiral should form. If there is no hand-drill available a simple jig of the kind illustrated opposite will produce the same result. Make a groove in a piece of hard wood (approx. 3 cm. × 10 cm. − 1¼ in. × 4 in.) to take the wire. The bar and wire should be held together in a screw clamp, with the wire in the groove, and the bar resting above it. The piece of wood should be placed in the screw clamp which must then

Spiralled wire.

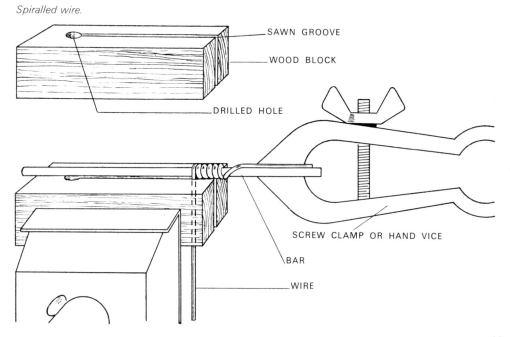

SAWN GROOVE

WOOD BLOCK

DRILLED HOLE

SCREW CLAMP OR HAND VICE

BAR

WIRE

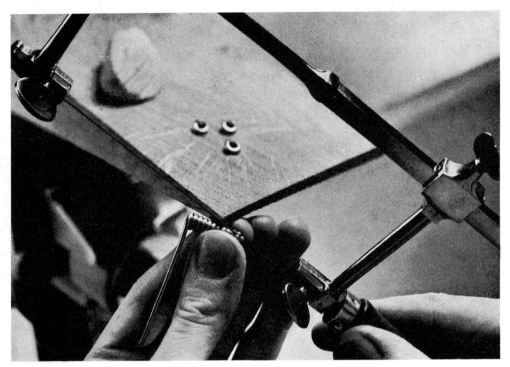

The spiral being cut through lengthwise with a piercing saw, using blade no. 3/0.

be carefully tightened. When you turn the bar, spiral loops are formed, their regularity depending on your keeping the wire in the groove. This method is particularly useful when you are making a spiral from thick wire.

Annealing the spiral
No annealing of the spiral need be carried out if the loops are to be coupled. If soldering is required, the spiral must be annealed, pickled and scoured with pumice powder.

Sawing the loops
Using blade 3/0 on the piercing saw, the spiral loops are sawn through along the length of the spiral. To ease this task, the blade may occasionally be given a touch of beeswax. Saw blades are available from 3/0 (fine) through 0 (medium) to 5 (coarse). There is also a Swiss 8/0 which is extremely fine. The grade of saw blade used depends on the thickness of the metal.

Coupling the loops together
With two pairs of flat pliers, the loops are joined together as close as possible. To avoid damage to the loops, use smooth-jawed pliers.

Summary of work schedule (chain with three pairs of loops)
1. Prepare a spiral with, for example, 1 mm. wire on a 3.5 mm. bar.
2. Saw through the required number of loops.
3. Couple together three pairs of loops (six loops altogether).
4. Stick the first pair together with adhesive tape to make assembly easier.
5. Open the loops of the third pair as far as possible.
6. Open the loops of the middle pair in the same way.
7. Bring forward the loops of the third pair between the loops of the second pair.
8. Couple together a second set of three pairs of loops (six loops) as in 3. above, attaching the first pair of the new set to the third pair of the first set.

CUT LINK

ENDS BENT APART

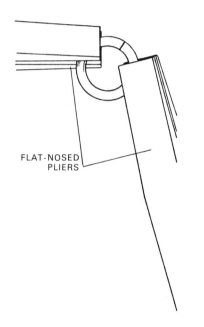

FLAT-NOSED
PLIERS

CLOSED JOIN

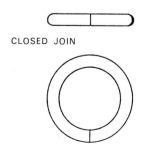

Catch

The catch generally consists of a spring bolt ring, of a size to suit the loops — the catch should not be conspicuous. In some cases it is necessary to add a small loop close to the catch to keep the chain straight. The catch should not be annealed or dipped in sulphuric acid because it would lose its natural springiness, and the acid would cause rust, rendering the internal spring useless.

Oxidation (colouring)

If the chain is made of silver wire, it will need chemical oxidation to bring out the lustre of the silver in contrast with the darker shades between the loops. Oxidation involves immersing the chain in a liver of sulphur pickle (see p. 25). Pulverized pumice stone, dampened with water, should be used for polishing.

Final polishing

This is best done on a machine with a full range of different polishing materials. If a machine is not available, polishing can be done by hand using steel wool 000.

Washing

Any grease can be removed by dipping the object into a detergent solution.

Making chains with oval loops

A special oval bar is used, the bar being first covered with paper before the wire is bound on to it. This is necessary to enable the wire spiral to be removed — the paper is burnt off, leaving a gap between the bar and the spiral. If the loops are to be soldered, it is important that the joins are turned so that they face each other, and therefore hide each other (see illus.). With oval rings the joins are best placed at the end of each ring.

SOLDERED
JOINS

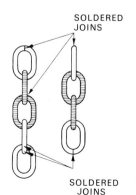

SOLDERED
JOINS

Soldered chain with oval links. It is important that the joins are turned to face each other.

45

Three pairs of sawn-up links are coupled together and then bent apart to be coupled with the next three pairs. The first pair remains untouched, on the second pair the ends are bent apart, and the third pair is brought forward between the links of the second pair, ready for the next coupling.

Opposite above: chain of 2-pair links, join unsoldered.

Opposite below: chains of 3-pair links, joins unsoldered.

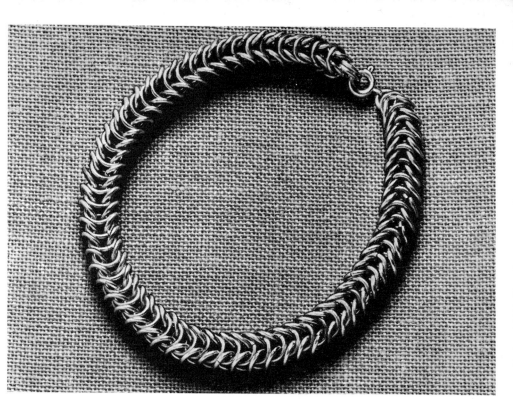

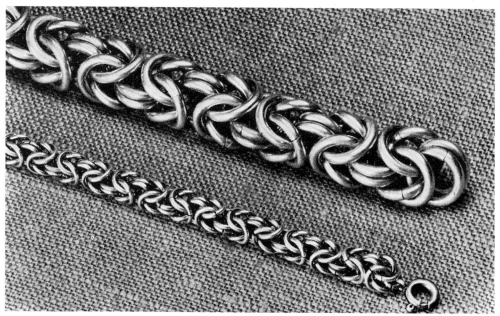

Rings

Making rings

A plain, simple, finger ring is the foundation of all ring-making: the various stages are described below.

A ring measure consists of a large metal ring to which are attached a range of rings covering all the standard sizes. They are used to measure fingers for rings. When trying on a ring, it should not slide too easily over the knuckle.

When measuring the length of metal to form the workpiece for a ring, at least double the metal thickness should be added to the measured circumference. This applies to the average ring; for very wide rings more should be added.

A ring is measured on a measuring stick, graded to give both the inner diameter (for example no. 17 is 17 mm.) and the circumference (for example no. 53 is 53 mm.). If the ring is too large, reduce its circumference by cutting off a little at the seam. Lay the edges together again, solder, and shape the ring on a triblet (known also as a mandrel). If the ring is only a fraction too small, it can be stretched on the triblet by hammering it. For a much greater diameter increase, say from 16 mm. to 18 mm., an additional 6 mm. piece of metal would have to be soldered in.

Ring with concave profile

1. Cut a piece of metal to the desired width and length.
2. Bring the ends carefully together with round-nosed pliers. For coarser metals, a mallet or hammer is better. The photographs on the right show these first two stages.
3. Hard solder the seam.
4. Shape the ring on the triblet, at the same time ensuring that the metal is of equal thickness all round.
5. Shape one edge of the ring by placing the ring on an anvil, hammering outwards with a conically-shaped steel rod — (a) on diagram opposite. Alternatively, use a blocking hammer lightly tapped by a mallet (c).
6. Repeat this shaping on the other edge of the ring (b).

Ring measure, two measuring sticks and a ring triblet.

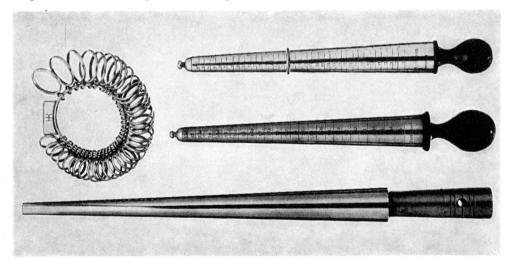

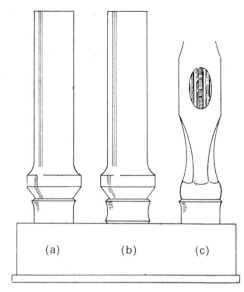

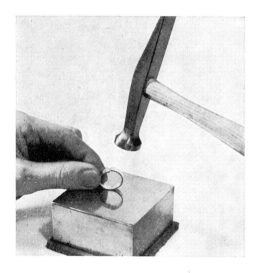

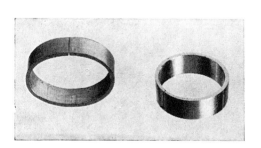

Left: the piece of metal being shaped and hammered into a ring shape.
Above: making a concave profile.

Signet ring

The illustration on p. 50 shows a ring made from two silver plates (on which the inner measurements of the ring have been marked by a pair of dividers), a band, and an upper plate which, if desired, can be decorated.

Stages in making the ring

1. Cut out two square silver plates (1.25 mm. thick).
2. Measure the inner diameter with a pair of dividers, and drill a hole, approximately 1.5 mm wide, where marked: cut out the unwanted discs.

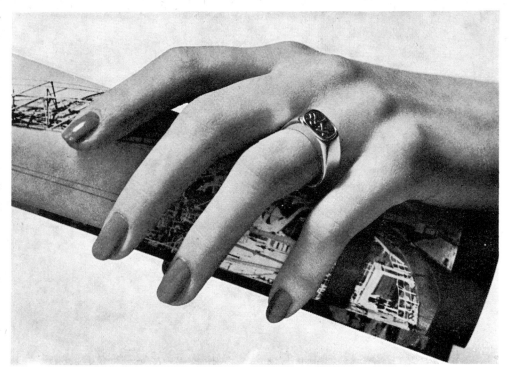

Signet ring.

3. Cut out the ring band.
4. Bend the ends to form the greater part
of a circle.
5. Hard solder the ring band, keeping one
edge straight against a flat surface.

3

5

4

6. Cut off any projecting metal.
7. Hard solder the ring band at the hole in the plate. Tie the parts together with thin soft iron binding wire.
8. Cut off any projecting metal. File the edges and polish with emery cloth.
9. Solder on the metal plate, decorated if desired.
10. File off any projections from the edges.

Monogram ring

If the monogram ring is thick and broad, shaping is best carried out using a hollowed wooden shape and a round piece of wood, as in the illustration at the bottom of the page. Use hard solder.

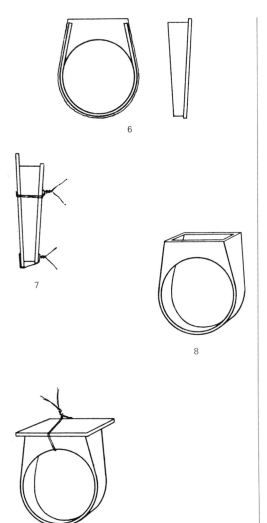

6

7

8

9

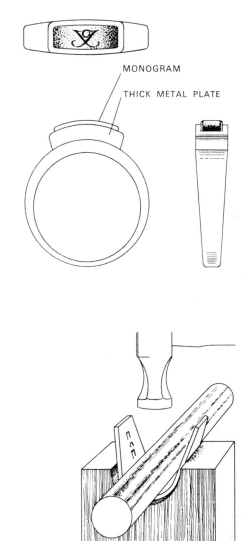

MONOGRAM

THICK METAL PLATE

Open-ended ring

Use thick metal for this type of ring – say 1 mm. for a broad ring. Shape the ring on a triblet – it will get out of shape more quickly than a joined ring. The length required can be determined by measuring with a piece of round wire of the same thickness as the ring.

Altering the size of a ring

To alter the size of a ring containing a pearl or other precious stones that could be adversely affected by heat, fill a bowl with damp sand and sink the precious part of the

ring into the sand, leaving only the metal exposed. Hard soldering can now be carried out—take great care and use a really hot flame.

Neck ring

These are often used for suspending pendants: use round wire of 1½–2 mm. diameter.

Twisted wire for rings, bangles etc.

One set of wire ends should be pressed together in a screw clamp (see p. 43), and the other ends tightly clamped in a vice. The wires being twisted are lightly pulled to

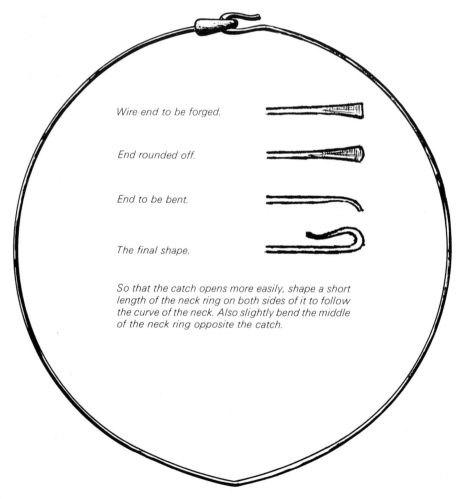

Wire end to be forged.

End rounded off.

End to be bent.

The final shape.

So that the catch opens more easily, shape a short length of the neck ring on both sides of it to follow the curve of the neck. Also slightly bend the middle of the neck ring opposite the catch.

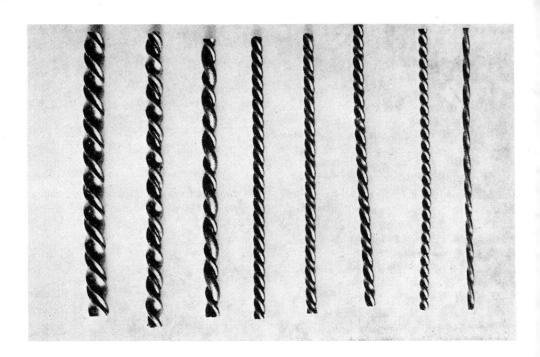

ensure a regular pattern. The wires must all be evenly annealed and therefore soft. A variety of patterns can be created by twisting the wires in different ways. The wire is spiralled for the required length, sawn through with a piercing saw, fitted together and soldered. The ends must abut closely. Tiny pieces of hard sterling solder should be used.

2 round wires

2 flat wires

1 round, 1 flat wire

1 round, 1 flat, 1 round wire

1 flat wire

Wire sections

These four pages show some ideas for pendant designs.

Brooches

Clasps for non-precious metal brooches

For brooches made from non-precious metals, clasps are soldered on to the brooch. These clasps can be bought ready-made in a number of designs, with or without safety catches, and in lengths from 2 cm. ($\frac{3}{4}$ in.) to 4 cm. ($1\frac{1}{2}$ in.). Purchased settings, clasps etc. are known as 'findings'.

Positioning the clasp

Choose a clasp whose length suits the size of the brooch. A longer clasp will make the brooch more resilient. When positioning the clasp on the back of the brooch, point the hook to hold the pin downwards — this will reduce the risk of the brooch being pulled

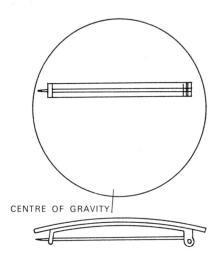

CENTRE OF GRAVITY

A selection of pins and clasps, with and without safety catches, for non-precious metal brooches.

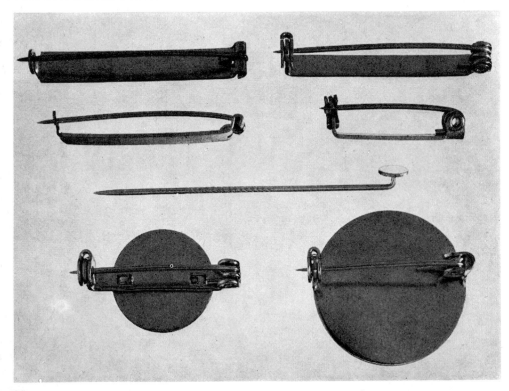

58

Above: the straight fitting has been bent to the shape of the brooch. The pin should also be slightly bent to grip better.

away from the garment on which it is worn. Remember also to shape the base of the clasp to follow the curve of the brooch; the pin should be curved to the same shape. The clasp for a circular brooch should be placed slightly above centre, i.e. in the top half of the brooch as worn (see diagram opposite).

Soft soldering clasps to non-precious metal brooches *(see diagrams 1-4)*.

1. Apply flux to the clasp.
2. Place strips of soft solder on the back of the clasp.
3. Melt the solder strips with a gas flame, either from above or below.
4. Apply flux to the back of the brooch and the top of the clasp.
5. Place the clasp on the back of the brooch. Heat the clasp as well as the areas to be soldered. Since the brooch requires a stronger heat on account of its thickness, this operation requires care. Hold the clasp in place with tweezers, a clamp, or binding wire.
6. Leave the brooch to cool. Then rinse and dry.
7. File away any solder that may have over-flowed. On a perfect solder join the solder will be spread evenly round the piece.
8. After soldering, any decoration should be oxidized.

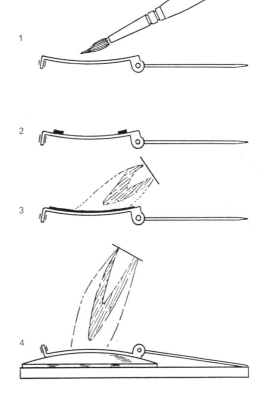

9. Wash the brooch in a detergent solution containing a little ammonia to neutralize the acidic flux. Dry carefully with a clean cloth.

Design suggestions for ear-rings. These could also be adapted for brooches and pendants.

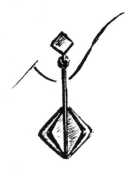

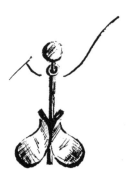

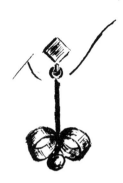

Clasps for gold and silver brooches

You should not use cheap findings as clasps on gold and silver brooches. The separate items — pin, catch, and chenier — are not difficult to assemble. Make the pin from round wire about 1 mm. thick. Shape one end using a pair of pliers — the diameter of the loop should be about 1·5 mm. (1, below); any projection should be sawn off with a thin blade (2). If the pin is very soft, hold each end of the wire in a pair of flat-nosed pliers, and twist it backwards and forwards. When the pin is placed in the hinge (chenier), nip off any excess length (2 mm. or more from the catch). File this end of the pin to a point. To fix the pin, insert a length of 1 mm. wire (3), and squeeze the protruding ends with pliers (4), to form a rivet (5).

Some examples of clasps are shown below.

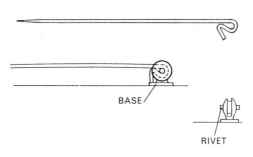

BASE

RIVET

Above: one method of making a fastening that is in tension.

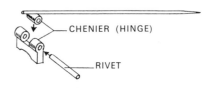

CHENIER (HINGE)

RIVET

Above: assembling a hinge.

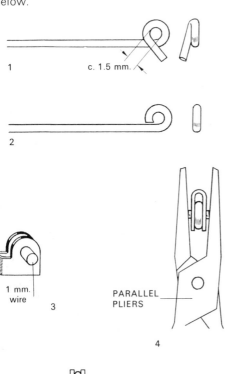

1

c. 1.5 mm.

2

1 mm. wire

3

PARALLEL PLIERS

4

RIVET

5

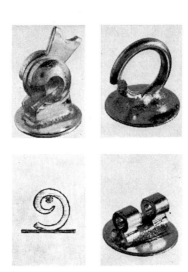

Above: various clasps and chenier, all ready for easy soldering.

Findings

There is a wide range of semi-manufactured findings on the market that can be used as a basis for making your own jewellery — cuff-links, ear-rings, necklaces and so on. The illustrations on p. 66 show the most common types and their function.

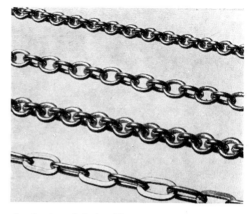

A selection of chains. These are sold by the foot or metre, and come in a variety of widths and metals — silver, nickel silver, gilding metal etc.

A plastic storage tray with compartments is very useful for storing small objects that are easily mislaid.

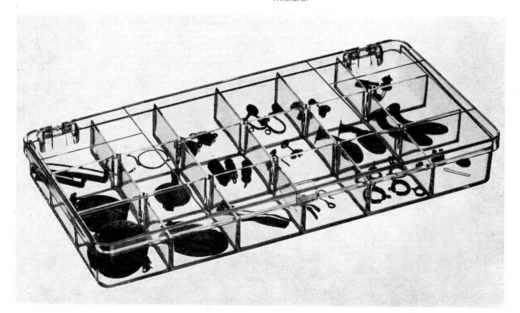

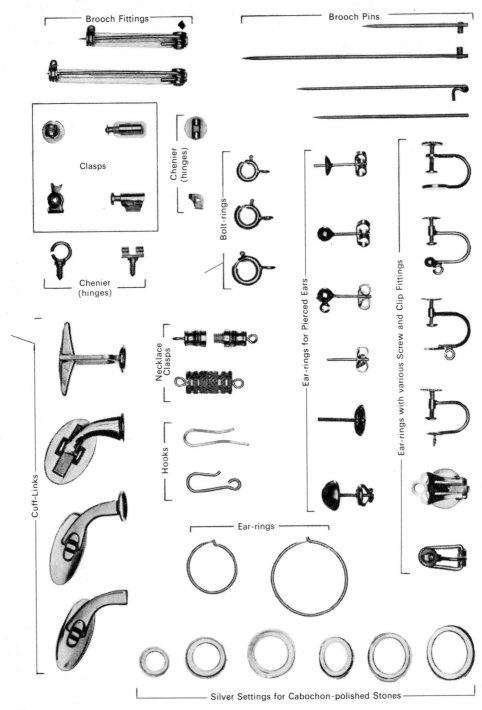

Brooch Fittings

Brooch Pins

Clasps

Chenier (hinges)

Bolt-rings

Chenier (hinges)

Necklace Clasps

Ear-rings for Pierced Ears

Ear-rings with various Screw and Clip Fittings

Cuff-Links

Hooks

Ear-rings

Silver Settings for Cabochon-polished Stones

Pommels

Pommels are hemispherical raised ornaments, used on brooches and rings. But they can also be functional, acting for instance as supports for bowls (see p. 37). Pommels can be made separately, or can be soldered or hammered straight on to the piece. The technique for making pommels is similar to that for making bowls.

Doming blocks
These are steel cubes with a number of hollows of various sizes and depths. They are used for shaping hemispherical decorative details straight on to an object, or for soldering them on afterwards. Individual pommels can be made from small round discs. The edge of the pommel must be filed smooth before you solder it.

Making pommels
The doming block rests on an anvil, which should be covered if it is polished. The tools needed for making pommels are a chasing hammer and a mallet. Keep moving the piece of metal you are working on, so that it is evenly shaped. Use a large hollow to start with, and then continue with smaller and smaller ones.

For larger pommels a blocking hammer is more suitable than a punch, in which case a mallet should be used for hammering. When you are working on very small pommels hammer them with a small ball punch, using several hollows.

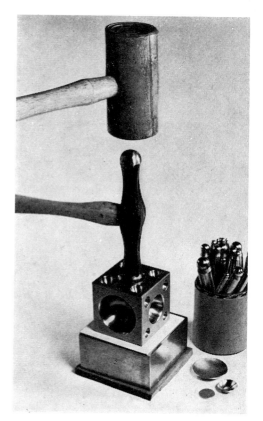

When making larger pommels, a blocking hammer is more suitable than a punch.

Decorative techniques

Engraving

Zig-zag patterns

The creation of zig-zag patterns is the most common way of decorating metal surfaces – practise on odd scraps of metal first. A square graver can produce a wide range of patterns: it is moved along the metal surface, working right and left in an even rhythm. The pressure exerted on the graver, and its speed, whether sideways or up and down, control the patterns. The quicker the rhythm, the closer the pattern.

Gravers

These tools are sold without a handle; separate handles can be bought in a variety of designs, and should be suited both to the length of the graver and the size of one's hand. The handle should fit snugly against the pad of the palm in the pushing position, and the cutting tip of the graver should be about 2 cm. (1¼ in.) longer than the thumb. One side of the handle is very often sawn off to avoid contact with the metal on which the graver is being used. When bought, gravers are invariably too long; to break them off at the correct place hold the required length in a vice, and give a sharp blow with a light hammer to the unwanted section. Graver sizes relate to their section, and in Britain are graded in tenths of a millimetre. Thus a graver of section 1 mm. is size 10. In the U.S. they are graded in thousandths of an inch.

Gravers can be ground against a fine texture emery wheel. Now and again the graver should be dipped in water to avoid drawing the temper. After grinding, the face

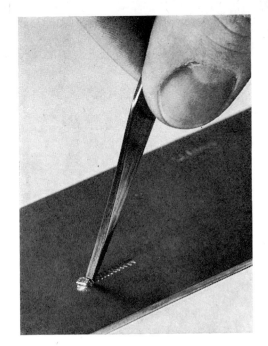

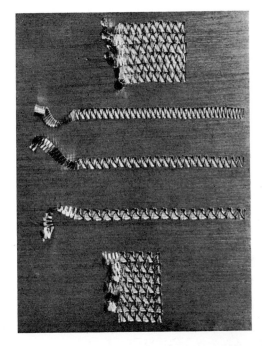

Above: zig-zag patterns are created by moving a square graver along the surface in an even rhythm, turning the graver left and right.

Right: the top single line was created by quick movement with the graver, the two bottom single lines by a slower one.

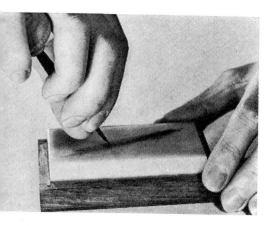

It is important to hold the graver at the correct angle when it is sharpened against the oilstone.

and tip should be polished with emery cloth. The first stage of sharpening should be carried out on a medium/fine emery or India oilstone. The final sharpening should be done on an Arkansas stone on to which some sewing machine oil has been dropped. It is important to hold the graver at the right angle while it is being ground. To finish off, the edge of the tool should be stropped on a piece of leather to ensure absolute sharpness; test it against your thumb-nail. The oilstone can be cleaned with benzene or ammonia, and is also useful for sharpening scrapers, knives and small drills.

Grinding gravers (if no emery wheel is available).

1. The point should be cut, and for this purpose the graver is clamped in the vice,

Sawing off one side of the graver's handle stops it rubbing on the metal, and also prevents it from rolling off the workbench.

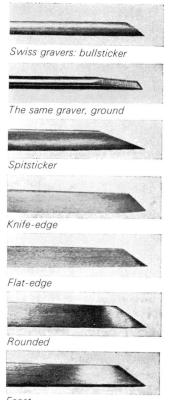

Swiss gravers: bullsticker

The same graver, ground

Spitsticker

Knife-edge

Flat-edge

Rounded

Facet

leaving about 1 cm. ($\frac{3}{8}$ in.) of the point visible – the amount to be removed.
2. The point is now ground against a medium-grained emery stone, at an angle of about 40°.
3. The sharp edges left by the grinding are removed with emery cloth.
4. The point should now be sharpened on the oilstone.

Chasing and repoussé

Chasing is a form of decoration on the surface of the metal, executed with small, blunt chisels and an assortment of punches. Repoussé as a rule involves imposing a design on the metal from *inside* the object, after which the finer details are chased in from the front.

Transferring the pattern
The pattern should first be drawn on a sheet of paper, ready to be traced through carbon paper on to the object. A highly polished metal surface will not accept a carbon impression, and the surface must be dulled or coloured. To produce a matt surface on a silver or copper object, anneal and pickle it, or paint the surface with Chinese white. After the pattern has been transferred, the lines of the design should be gone over in pencil or Indian ink, or scribed with a sharp steel point.

Chasing
Using a tracing tool and a chasing hammer, hammer the lines of the pattern into the metal surface. The tracing tool should have a rounded chisel-like point, but should not be very sharp. Hard pitch serves as a useful

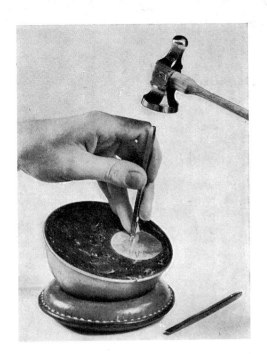

Chasing. The lines of the pattern are hammered into the surface. The object is fixed in pitch.

Ingredients	Hard pitch for embossing	chasing	Soft pitch for embossing
Black pitch	2250 g.	1000 g.	2250 g.
Resin	1750 g.	1750 g.	1250 g.
Clay	1250 g.	1500 g.	1000 g.
Gypsum	500 g.	1250 g.	250 g.
Talc	150 g.	50 g.	300 g.
Venetian turpentine (in tablespoons)	$2\frac{1}{2}$	$2\frac{1}{2}$	$1\frac{1}{2}$

Recipe for pitch. All the ingredients should be finely ground to avoid lumps. An old pan can be used for melting. Swedish pitch can sometimes be obtained from Electricity Boards – it is used in cable-laying, and any pitch left over is often discarded. Plaster or cement dust may be substituted for the clay, gypsum and talc.

support for the object when working; a vice or a lead base serve the same purpose. To ensure that the object is securely set in the pitch before working, both the pitch and the object should be slightly heated over a gas flame. Half a metal ball-valve ball, obtainable from a plumber, makes a suitable pitch bowl, but will need weighting with scrap metal pieces. When pressing the object down into the warmed pitch, take care that there are no unevennesses or air bubbles beneath the object. When the object has cooled, the chasing can begin.

Bowls, vases and candlesticks should first be filled with pitch so as not to damage their shape. If you are working a small object, use a vice or lead support, and soft solder the object on to a larger piece of metal to prevent it from slipping. It is vital to remove all traces of solder, because when annealing of silver or copper is to follow, any lead present will amalgamate and burn itself into the metal. If lead is used as the working base, take care

not to leave any trace of this metal on the object.

Repoussé

In repoussé decoration lines are tapped on the metal with a chasing punch, and a tracing tool is then used to punch raised designs into the metal, inside these guidelines. The chasing hammer is also used for this purpose. Punching is done from the back of the object, but now and again adjustments have to be made from the front.

Embossing

Embossed decoration consists of a punched design, worked from the back only; this is often in fairly high relief. Most embossing punches have rounded tips (see illus. below).

If the design calls for decorative motifs such as leaves, a shallow wooden former can be used as a base. If working over a lead base, a chasing hammer or punch can be used to make a hollow to fit the ornament being worked.

Design punching

With a detail that has to be repeated several times, such as a flower or a leaf, a special punch can be made with this design on it. The design is then hammered into place from the front of the object on the tip of a punch.

Matt punching

A matt punch is often employed to produce a surface effect, decorative in itself, to act as

Nest of punches including repoussé punches, chasers and ball punches.

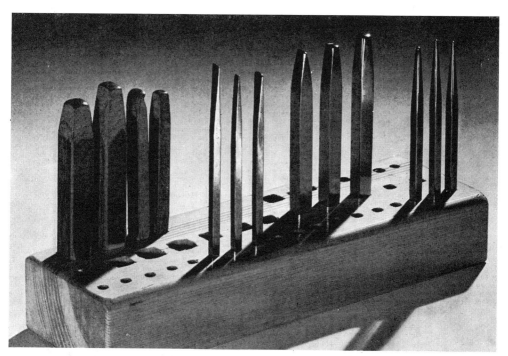

a contrast to the larger polished surface of the object. For instance, matt punching round an embossed patterned design could further enhance that design. The tip of the punch will vary, of course, according to the type of work being undertaken and the shape and size of the object. It is easier to work with a blunt pointed matt punch, since you can approach the point of application from any angle. The pattern is made by moving the punch in a controlled manner across the surface, and at the same time tapping it lightly against the metal.

Making your own punches

The most suitable material for home-made matt punches is silver steel. A double cut old file would be ideal to make the design for the tip of a matt punch, and would also render the surface smooth and matt. For this, the lower (tip) end of a punch is held in a pair of tongs and annealed; while the punch steel is still red, its tip is pressed against the old file. The punch is then cooled. Its hardness can be tested by running the file along the edge of the tip — if this is easy, the punch is hard. Should the metal be too soft, however, it can be re-heated to cherry-red, quickly quenched in cold water, and allowed to cool. The tip of the punch should be well polished before starting on the hardening process.

Type of steel	Carbon content %	Use
Carbon tool steel	1.2	Files
Carbon tool steel	1.0	Drills, wood-working chisels
High carbon steel (silver steel)	0.9	Knives, punches, chisels
High carbon steel	0.8	Hammers
High carbon steel	0.7	Pliers
Medium carbon steel	0.6	Screws, bolts etc.

Tempering now follows, which has the effect of softening the steel a little. Polish with a fine emery cloth, and then heat the centre of the punch over a gas flame. The metal will gradually change colour, and when the tip turns brown, dip the punch immediately into cold water. After polishing with emery cloth, the punch is ready for use.

When making a punch with a design, the pattern has to be made in reverse. After processing, polish the tip with emery cloth.

The above method for hardening and tempering can be applied to all small tools.

Etching

Etching involves the use of corrosive acids to eat away selected areas from metal surfaces. When working at professional level, a large variety of chemicals is needed, demanding great skill and careful storage and handling.

Any surface to be etched should start off in a mirror-bright condition. The object should be covered with a suitable acid resist to protect those parts of the metal surface not to be etched. Acid resists can be wax, pitch or shellac based, or a combination of all three.

The traditional resist is given as 20 g. each of beeswax and asphaltum, and 10 g. Swedish pitch, the wax and pitch being melted together and the asphaltum powder stirred in. This is then heated together gently for half an hour, and finally put into a cotton wool pad over which is stretched a tightly fitting piece of silk. This etching ball is applied to the heated piece of metal until a thin film of the resist or 'ground' is visible, and the metal is then left to cool under a cover. It is important that the resist covers all edges and surfaces. The design is then cut through the resist.

Quick drying resists can be made with shellac dissolved in methylated spirits and painted on thinly; asphaltum dissolved in pure turpentine; or asphaltum dissolved in petrol. Treat the last method with care. Self-adhesive plastics material is easy to use, but must be stuck very firmly all round the edge of the metal.

Etching needles

Etching needles resemble ordinary scribers; needles can also be made from hard wood, and small scraping knives from old files which have been ground to shape.

Etching acids

The acid used for etching on nickel silver, copper and brass is concentrated nitric acid, diluted 1:3 with water. For iron and steel a different nitric acid solution is used, i.e. 3 parts nitric acid: 4 parts hydrochloric acid: 4 parts water.

Any object with sides, such as a bowl, can simply have the acid poured in. Objects with more difficult shapes should be immersed in the acid in a glass, porcelain or plastic container. Gas bubbles will tend to accumulate, and should be brushed off with a feather or they may reduce the effectiveness of the acid. Nitric acid is highly active, giving off noxious fumes, and should be treated with great respect. Iron perchloride, used by printers for etching, is safer but requires a face-down position as a sediment is formed which must be allowed to fall out.

The rate of etching must be tested from time to time; the state of the etching ground must be checked for holes, and in the case of nitric acid for undercutting and lifting of the resist. Iron perchloride bites deeply with no undercutting, and is therefore ideal for line etching.

Method

Slightly heat the object. Apply the resist as above. Use an etching needle or a wooden stick to scribe the design through the wax film. The metal along the lines to be etched is thus laid bare. There are other ways to transfer the design, for instance a red pencil or tracing paper as described in the section on chasing. The acid is applied on a wooden stick wound with cotton wool, the stick being moved along the scribed line. The wax layer must completely cover the rest of the surface.

Before embarking on any ambitious etching project, it is advisable to try out a practice etching, and time the process. The acid should be left to act on the metal for only a few minutes; then rinse the object in cold water. Should any adjustments be required, the process will have to be repeated and timed once more.

Oxidation of the etched lines, if desired, should be carried out before the wax is removed (see *Oxidation*, p. 25). Copper and brass are very suitable and the method is a useful one for making name plates. To remove the wax, the object is gently heated over a hot plate and wiped. Finally, for a thorough de-greasing of the metal surface, dip the object in a bath of warm water to which a little ammonia has been added. If desired, the surface can be varnished, using Canning's Ercalene or a similar product.

Enamelling

Types of enamelling

Enamelling can be defined as the firing of a special, comparatively easily melted glass mixture on to metal. It is a similar process to glazing ceramics. The powdered glass mixture used in enamelling is composed of felspar, quartz, soda, borax, calcium phosphates and kaolin. The addition of metallic oxides produces a variety of colours.

The jewellery industry uses platinum, gold, pure silver, sterling silver, electrolytic copper, gilding metal and iron for enamelling. Some types of enamel can be applied to a whole range of metals, but it is advisable when buying enamel to state the particular purpose for which it is to be used.

Some of the metallic oxides lend colour to the enamel without otherwise changing its transparency. Others render the enamel opaque without changing its colour. According to the appearance of the finished enamel it is called, regardless of the colour, transparent or opaque.

A third type of enamel is the totally colourless, transparent ground enamel, fondant, which is used as a base on metals to give the colours of the transparent enamels a more attractive lustre. It is sometimes called 'clear flux' by suppliers. The transparent enamel is laid on top of the fondant, which can be bought for a variety of bases, such as copper, gilding metal, pure silver, sterling silver and gold. It is also produced for various melting temperatures and is classified as soft, medium and hard. The normal melting point of enamel is 700–800°C.

Small objects for enamelling can easily be heated over a gas flame; for larger ones a special muffle furnace is required. The appearance of the finished work depends wholly on the enamelling techniques used. Although no advanced techniques are discussed in this book, very attractive results can be obtained by following the methods described, and more advanced work can be attempted when the basic techniques have been mastered.

Enamel is either translucent or opaque. 'Translucent' nowadays is usually referred to as 'transparent', but this should not be confused with the technique bearing this name described below (also known as *plique à jour*). Enamelling can be divided into goldsmith enamelling and enamel painting, depending on the method of treatment. Enamel painting involves painting with enamel colours on a base coated with white opaque enamel. The underside of the base should also be coated with enamel to prevent cracking. Goldsmith enamelling can be divided into five types, according to the method of applying enamel to the base. The two of earliest origin are cell enamelling, normally called cloisonné, and champlevé.

In cloisonné the pattern is controlled by thin outline plates soldered on to the base. These cells are filled with enamel and fired.

Basically, champlevé is similar to cloisonné, the difference being that in champlevé the cells to receive the enamel are carved out with gravers and scorpers. Champlevé requires a fairly thick base, the most commonly used metal being copper or bronze. Gilt is very often applied to the visible surfaces.

The third type of goldsmith enamelling — relief enamelling (*baisse taille*) — is similar to champlevé, except that the bottoms of the cavities are carefully etched in low relief. These cavities must be filled with transparent enamel to allow the relief to stand out very clearly and show to full advantage the bright colour of the enamel. The intensity of the colour will vary with the depth of cutting into the metal.

Enamel may also be applied as a surface coating on relief, so that the relief retains its shape. This process, where the relief clearly projects and occasionally forms a separate miniature embellishment, is called enamelling on high relief.

Finally, enamel can be fused on to an open wire framework in the manner of leaded windows. The enamel will then have no base and be transparent: hence the term transparent enamel (*plique à jour*).

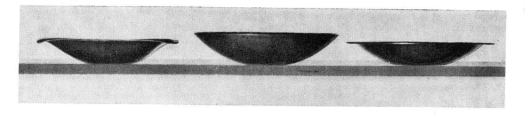

Enamelled ashtrays made from 1 mm. copper sheet.

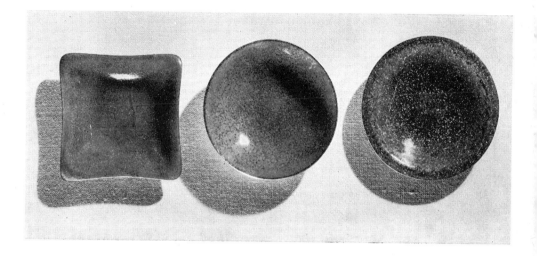

Ashtray made from 2 mm. copper sheet. Note the incidental 'beaten' decoration as a result of planishing.

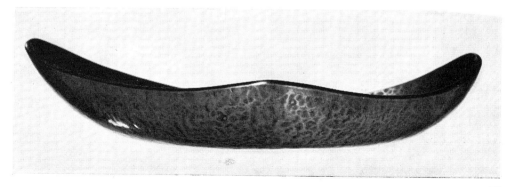

Suitable articles for enamelling

The illustration on this page shows some simple pendants made of 1 mm. copper. From left to right the surfaces are flat, convex, and the last two concave. The loop at the top of the first three can easily be cut from the same piece of metal as the object, and bent backwards. Alternatively, make the loop separately, and solder it on at the back after polishing and enamelling. Only the best quality electrolytic copper is suited to enamelling.

The three supports on the enamelled ashtray opposite are hammered out using a ballpunch (see p. 71). A 'pearlhole' punch, fastened in a vice, should be used as an anvil. As an alternative to supports, the bottom of the bowl can be hammered out against a round piece of wood (see p. 35).

Simple copper pendants suitable for enamel work.

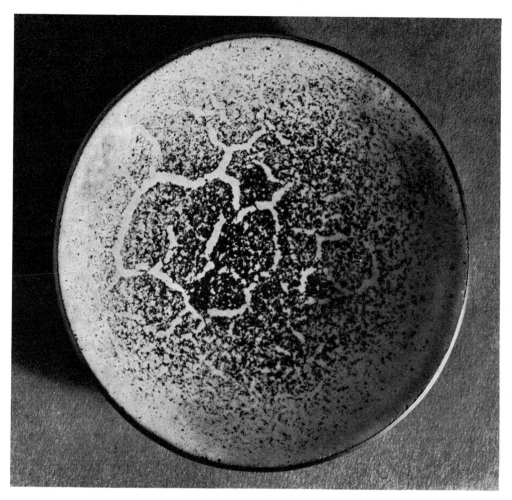

Enamelled ashtray, top and side view.

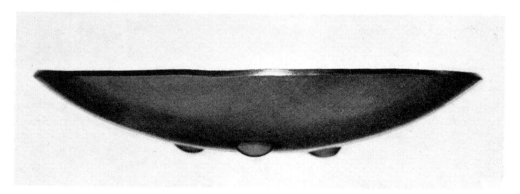

Preparation

Whether an object is to be enamelled all over or only in part, it must be annealed, pickled, cleaned and de-greased. If the metal surface is not absolutely clean and grease-free, the enamel will contract instead of spreading itself evenly. Rinsing and drying must follow immediately after the de-greasing operation.

Annealing
The object should be heated over a gas flame until the metal acquires a reddish tint. When heated, the metal gets softer and loses its tension. The object should then be left to cool or be dipped in cold water.

Pickling
The dark oxide formed during annealing is removed by immersion for a few minutes in dilute sulphuric acid. Afterwards the object should be thoroughly rinsed under a running tap, and dried. The pickle, consisting of 1 part concentrated sulphuric acid and 9 parts water, may be cold or warm, but should not reach boiling point because dangerous corrosive gases would be produced. Preparations should be undertaken with great care (see *Chemicals*, p. 90). This pickle can be used for most metals, i.e. gold, silver, copper, brass, and nickel silver, but not iron,

Wire brush for cleaning.

which should be pickled in a separate bath because if it comes into contact with silver, the silver will turn red.

Cleaning
Thorough cleaning with a brass cleaning brush and ordinary household detergent will produce a polished surface. For flat surfaces steel wool grade 000 can be used with detergent.

De-greasing
As already mentioned, enamelling will only work on a grease- and oxide-free surface. The de-greasing process should take place immediately before enamelling, and can be done in three ways. (1) Dip the object in water — if the water forms separate pools on the surface the metal is still greasy and will have to be cleaned again. On the other hand, if tap water will flow evenly over the metal surface, it is absolutely clean. (2) The second

This pendant is still greasy — water has formed separate drops on the surface.

method, heating, involves burning off the grease by heating the object quickly over an open flame and then leaving it to cool. The surface will be damaged if it is heated for too long. (3) The metal can also be cleaned mechanically by means of a file and graver. But as any part that has been filed is seldom perfectly smooth, areas treated in this way should not be covered with transparent enamel. However if it has been decorated with a graver (see p. 68), the transparent enamel will be better able to retain the interplay of colours.

The following solution is suitable for degreasing silver objects: 1 part caustic soda (sodium hydroxide 98–99%) and 9 parts water. The object should be immersed in the boiling solution in a refractory stoneware dish. After a few minutes it should be lifted out with a pair of tweezers and dried on a clean piece of cloth or paper. Keep your hands away from the newly cleaned surface.

Before applying transparent enamel to objects made of copper or gilding metal, you should immerse them in a pickling solution of 1 decilitre (about $\frac{1}{5}$ pint) concentrated nitric acid, and $\frac{1}{2}$ a teaspoon of salt (sodium chloride). This should be stirred with a glass rod or wooden stick. This acid is very strong and the fumes it gives off are highly poisonous, so the whole operation must be carried out in a well-ventilated room.

Above: enamel. From the left: large pieces of frit, coarse ground enamel, powdered enamel, enamel beads, and enamel thread. Enamel beads can be made by firing small pieces of frit on stainless steel or cupronickel and flexing them off when cool. Enamel thread is easily made by melting a lump of frit with the blowtorch and drawing threads from it with a piece of pointed steel wire.

Below: equipment for enamelling. From the left: storage jars, mortars and pestles of glazed ware and agate, tray with brush, bottle with pipette, and glass feeder.

Applying and firing enamel

Grinding enamel

Enamel can be bought powdered, in lumps, or in sheets. To save time, powdered enamel is recommended, but it should be washed before use. It can be used directly as a powder by being sifted on to metal previously coated with enamel glue. Another method is to mix the powder with distilled water to form a paste, which is then applied with a hard brush or a spatula.

Coarse enamel must be ground using a porcelain mortar and pestle, then ground again using an agate mortar. The powder produced requires rinsing in several changes of water, with a final wash in distilled water. Transparent enamel must not be ground so finely as opaque, or it may lose its clarity and sparkle.

Rinsing

Powdered enamel normally contains impurities; it should be placed in a mortar, and a large quantity of distilled water poured over it. Stir the mixture with a pestle or spatula and allow the enamel to sink to the bottom. Now pour the cloudy water away. Repeat the process until the water is completely clean. Opaque enamel is normally ready for use after a couple of rinses, but transparent enamel needs a little more attention. Any enamel waste should be kept, as it can be used for counter-enamel (enamelling the back or underside of an object).

Preparing the surface

Sifted dry enamel and enamel paste should be applied only to surfaces already treated with adhesive, so that the powder remains in place for firing. The metal surface should also be treated before using enamel paste. Apply the gum with a small brush. With large surfaces it is easier to paint one area at a time and apply the enamel mixture immediately to prevent the gum from drying out, or else you can spray the gum with a mouth spray. Gum is not essential for small flat surfaces, which can be moistened with distilled water.

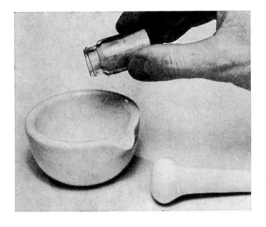

Enamel powder is placed in a mortar.

Distilled water is added.

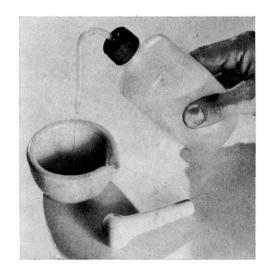

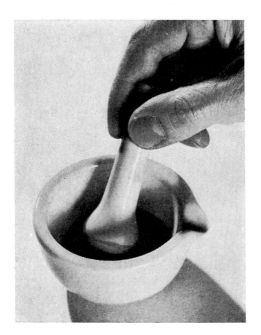

The mixture is stirred with a pestle.

The cloudy water has been poured off into the bowl on the left, and now fresh distilled water is being added to the enamel mixture'.

Trial runs

It is advisable to test the enamels first on a scrap piece of identical metal. This sample should be given exactly the same treatment as the object itself, i.e. polishing, pickling and de-greasing. It is also worthwhile noting the numbers of the enamels and the order in which they are applied. On the basis of these results you can then decide on any changes that need to be made in treating the actual piece. This is particularly important in transparent enamelling, where the thickness of the enamel is a controlling factor in the balance of colours. The test strips can also show you whether or not the enamel can stand up to pickling and whether the pickling process will darken the enamel colours. Black and white enamels should never be pickled.

Changing the colour of the enamel

If you want to alter the colour of an enamel that is suitable in other respects, you can weaken the colour by adding colourless ground enamel when you rinse the object. A thicker layer of enamel will result in a stronger, darker, less transparent colour. A complete change of colour in a transparent enamel can be obtained by laying the enamel on a fired opaque enamel ground. You can create a most striking effect on a glossy enamel surface by mixing together coarsely ground enamels of different colours.

The thickness of the enamel

The enamel should be applied with a brush or spatula, or else sifted through a fine strainer. Generally speaking, transparent enamel is applied more thinly than opaque enamel, as this makes it even more transparent. If applied very thickly (say $\frac{1}{2}$ mm.), a transparent enamel may look almost black. It is advisable to enamel transparent colours on a suitable flux (fondant) — silver flux, copper flux etc. The base colour will thus be less dense and the finished product will have additional sparkle. If the layer of transparent enamel seems too thin after firing, another layer can be added.

When laying opaque enamel on top of transparent, the thickness of the layer of powder need not exceed that of the previous

layer. However if the opaque layer is to be set directly on the metal, it should be thicker than that of the transparent enamel, i.e. about 1 mm.

Enamelling with powder and paste

Only a slight difference separates the two methods described in this section. Enamel powder must be perfectly dry.

Method 1 (powder)

1. Paint the de-greased metal surface with a thin layer of enamel gum, of the consistency of thin cream. If it is too thick it can be thinned with distilled water.

2. Place the object on a piece of paper. Sift, through a fine-meshed tea strainer, a thin layer of enamel powder on to the gummed surface. The layer of enamel should be about $\frac{1}{2}$ mm. thick for transparent enamel, and 1 mm. thick for opaque enamel.

3. Set the object on an iron rack or grid of more or less the same shape as the object. Larger objects must also be counter-enamelled – this merely means enamelling the back or outside of the surface being decorated, to prevent stresses being set up between the material and its enamel coating, which might cause the enamel to crack. A muffle furnace is required for these larger objects.

4. Anneal the object from below. The gas flame must not be directed against the enamel, and the annealing should be performed slowly, gradually increasing the temperature. If the powder is not quite dry and the object is heated too rapidly, the enamel will flake off. Steadily increasing heat will ensure that enamel powder melts. Do not remove the flame until the enamel has all melted to a glossy, even consistency.

5. Place the object on an asbestos disc, or leave to cool on a rack.

6. Prick any bubbles in the enamel with a needle held in a cork. If there are patches where the metal surface has been exposed, the object should be pickled again to remove oxide. After the pickling, rinse as usual in clean water, brush, and de-grease. Apply enamel powder again, and fire the object; repeat the procedure until the surface is satisfactory.

7. To smooth off the enamel, it should be

Enamel powder is sifted over the gum-coated metal.

Stainless steel wire tools, for lifting objects to be enamelled.

ground with carborundum stone dipped in water from time to time. Alternatively a coarse emery cloth may be used. The enamel surface should now be cleaned and fired at the same temperature as before.

8. Remove any remaining oxides and surplus enamel from the edges and back of the object by pickling. If you are sure the enamel will withstand it, pickle the entire object (see p. 28). All oxides and surplus enamel should come off the edges and back after a few minutes. Then

rinse the object in cold water and clean the metal with a metal brush.

If you know the enamel will be damaged by pickling, emery cloth or steel wool should be used to remove the oxide from the metal parts. If this method is not wholly successful, use a wooden stick covered with cotton wool and dipped into the pickling solution. Any surplus enamel at the edges can be removed with an emery stick.

9. If the metal is scratched, treat it with emery cloth and then possibly with steel wool grade 000. Finally, polish the surface (machine polishing will give the best results). Take care not to crack the enamel.

Method 2 (paste)

1. Add distilled water drop by drop to enamel powder, stirring until the mixture has the consistency of a thick paste.

2. Place the object on a dust-free support and apply the paste with a spatula or hard brush. For small, delicate decorations a good quality, fine-pointed brush is recommended. Apply enamel evenly. Various colours can, of course, be put on alongside each other.

Bent steel wire for supporting the object to be enamelled. Apply the flame from below.

Combined knife and spatula, spatula, carborundum stone, and soft brush, and (left) scissors for cutting thin metal and wire.

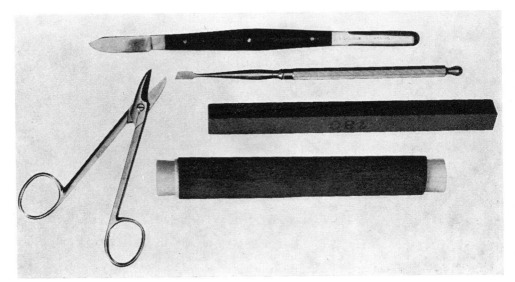

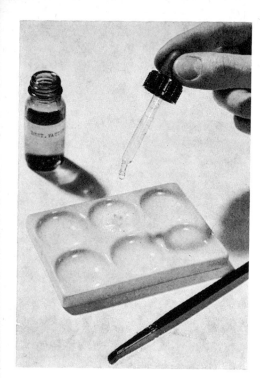
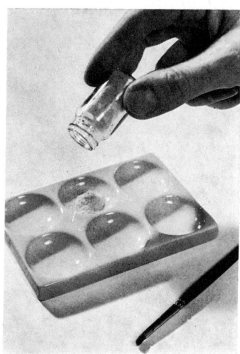

Enamel powder is mixed with distilled water added drop by drop. The mixture is then applied evenly, using a fine paintbrush.

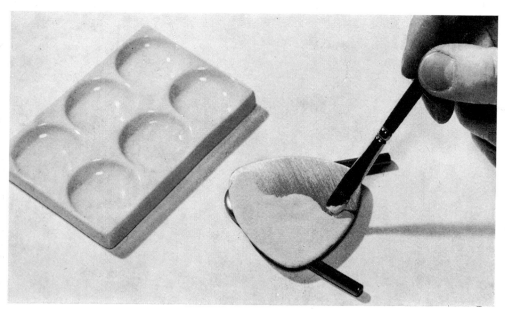

3. Tap the edges of the object carefully, to assist in settling the enamel evenly. Surplus water can now be soaked up with absorbent paper.

4. Allow the enamel paste to dry. For speed, place the object on a piece of asbestos on a tripod. A weak jet of gas, directed from below, will gently heat the metal, driving off the water as vapour.

5. Fire the enamel; free the metal from acids and oxides; polish as described in Method 1, stages 6–9.

Designs in enamel

Enamel thread

Small enamel threads can be applied to the glued surface to add a pattern of contrasting colour to the enamel base. (Do not confuse enamel thread with enamel wire (see p. 88), which is a particular form of cloisonné).

Straight and curved lines

Beginners find it easier to fill in the lines of a sunken design than to coat enamel over a complete object. Decoration of this kind might involve filling in a previously punched line with transparent or opaque enamel. Enamelling could be carried out in two stages, so that the indented line is filled up right to the surface of the object. After firing, the enamel is polished smooth and then re-fired to produce a glossy finish. Thread enamel can be used for straight lines and curves, by laying threads on top of the furnace and playing a flame over them till they begin to

melt. They can be bent with tweezers. If a large area is to be filled with enamel, the pattern can be driven in with a punch (see p. 70).

Sparkling effect

When whole areas are to be enamelled, for instance on cuff-links or signet rings, the surface can be given an added attraction by chiselling it (see *Etching*, p. 72). Transparent enamel is more suitable here, since it creates a sparkling effect against the metal base, particularly if laid on a clear flux.

Painted motifs

Two further simple ways of decorating an enamel surface are applying patterns direct with enamel glue, or using a paper stencil. In both cases the work is carried out on fired enamel. When the motif is to be painted on directly, a fine watercolour brush is used to apply the enamelling glue to an enamel base. The object is then placed on a piece of paper, and enamel powder is sifted through a fine strainer on to the glued surface. Any surplus powder is shaken off before firing.

When applying a pattern with a stencil, thin transparent paper should be used (this could be folded two or more times to make a repeat pattern). The cut-out motif is moistened in distilled water and pressed against the enamel base. A layer of adhesive is applied to the edges. Then apply the enamel paste with a brush on the glued parts, or sift enamel powder evenly over the paper. Now lift off the stencil very carefully. Before firing, the motif should be gone over with a clean, damp brush.

Lumps of enamel mixture are laid on an unfired self-coloured enamel, and an annealed steel needle used to make the design in the melted enamel. Lines may also be drawn to connect the enamel lumps in a more fluid pattern.

Multi-coloured enamelling

Self-coloured opaque or transparent enamel is laid direct on the entire working surface of the object. A few lumps of enamel mixture of varying colours are laid on a damp, unfired base and left to dry. To speed the drying, place the object on an iron grid resting on an asbestos plate. Dry enamel must be fired from below, with steadily increasing heat. When the enamel is melted, another gas flame is directed towards the enamel – this time from above – far enough away for the enamel not to get discoloured. Only experience can determine the optimum working distance.

Anneal a sharp steel needle in the upper flame. Linear or curved motifs can now be drawn from the melted lumps of enamel on to the coloured base. Easily-flowing enamel provides a fine-lined decoration; viscous enamel will make a thick-lined decoration. The object is now left to cool. To avoid discolouring, the upper flame should always be withdrawn first, followed by the lower one, effectively removing any carbon deposits.

Lump enamel

After applying enamel of the chosen colour, and firing, the lumps (of varying sizes) are glued on to the enamel surface and lightly fired until they are fused. The lumps should not be entirely sunk in the enamel – the rounded shape is attractive enough to leave as it is.

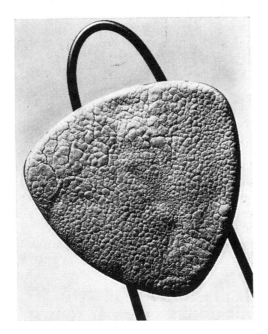

Crackle enamel

To produce crackle enamel, the entire object is coated rather more thickly than usual with plain transparent or opaque enamel. The object is fired from below until cracks begin to appear. Allow the object to cool; moisten the enamel with distilled water, and dry. The water will remain only in the cracks. Enamel of a different colour is then applied with the fingers. The second firing will produce a design along the cracks.

Left: after the first firing, the thick enamel layer is coarse and uneven.

After the second application of enamel the firing is repeated.

Crackle enamel. The cracks are filled with enamel of a different colour, the final firing producing a glossy, even surface.

Pencil drawings with enamel

A pencil drawing can be applied to a white enamel ground, by firing white enamel and grinding off the glassy surface, then drawing directly on to this ground surface with a soft pencil (a 4B is suitable) and re-firing. This can be most effective, and is very simple to do.

Using oxide as a colouring for enamel

Another attractive form of enamelling is produced by deliberately oxidizing a copper plate, removing areas of oxide by blowing or shaking. The plate is then sprayed with thin gum and coated with clear flux prior to firing. The result is an abstract design, caused by the clear colourless enamel flux picking up the oxide which goes into solution, effectively colouring the enamel.

Cloisonné (cell enamelling)

This is an old-established technique, called in France *émail cloisonné*, indicating that the object to be enamelled is first decorated with a pattern in metal wire heated into the ground enamel (fondant). Enamel, often in many shades, is packed into the cells that have been so formed. The boundaries of these cells can be formed by using either flattened, rolled wire, or rounded wire.

Cell formation with flattened wire

The metal surface is covered with ground enamel (fondant) and fired. A simple design, suited to the shape and size of the object, is transferred to the ground enamel by means of carbon paper. A number of pieces of flattened round wire (previously annealed and drawn) are shaped according to the pattern, taking care that the ends of the pieces do not overlap. Thus raised contours are formed around the details of the pattern, creating small cells. For copper objects, use electrolytic copper wire; for silver ones, pure silver wire. Any projecting wire ends round the pattern should be cut off with snips.

Draw wire accurately round the pattern to determine the exact length of wire required. Prepared and shaped wires, held by

Simple patterns like these can be made from round wire, fixed into the ground enamel by heating, and then filled with enamel in different colours.

tweezers, are coated with glue and positioned on the enamel surface. When the pattern is completed, the object is heated gently from below until the wires have sunk into the ground enamel. If any piece of wire has not fused, it must be carefully pressed down with a steel pin before re-firing. The wires should now be cleaned with a brush, and the enamel is then poured into the cells. Oxides are removed by pickling; the object is then rinsed under a running tap and brushed to remove any traces of acid.

Filling cells with enamel

Enamel of various colours is laid layer by layer into the cells. When dry, the enamel is heated from below. Transparent and opaque enamel can be used according to the design, which will also determine the number of layers and firings.

The cells should be slightly overfilled before finally grinding flat with a carborundum stone under water. It is at this stage that the Chinese enamellers considered a job finished, except for final polishing with pumice stone, leaving a beautiful eggshell finish. However, a final firing can take place to glaze the enamel surface, the cloisonné wires being polished by hand.

Chemicals

Acids

Chemicals for immersion, cleaning and etching must be readily available. Always take care when handling them — any acid accidentally splashed on to the skin should be washed off immediately with plenty of water. Chemicals should be clearly labelled.

Sulphuric acid (H_2SO_4)

Sulphuric acid is normally used only for immersion. Concentrated sulphuric acid darkens on exposure to dust, cork, straw etc., and should be stored only in the correct type of glass bottle with a glass stopper. On no account should sulphuric acid be mixed with turpentine or any other organic substance, or an explosion may be caused.

Nitric acid (HNO_3)

Nitric acid is used to provide the strongest type of pickle. A commonly used mixture consists of 1 decilitre (about $\frac{1}{5}$ pint) of concentrated nitric acid with $\frac{1}{2}$ a teaspoon of cooking salt (sodium chloride) — see p. 79. The salt is stirred into the acid using a glass or wooden rod. A poisonous gas is produced when these chemicals are mixed, so you should always work in a well-ventilated place. The object to be pickled should be immersed for only a few seconds, washed under running water, and dried. Copper pieces to be enamelled are first pickled in sulphuric acid, rinsed, dried, and then quickly dipped in nitric acid solution, rinsed again in clean water, and finally dried again.

Hydrochloric acid (HCl)

A mixture of 3 parts of hydrochloric acid with 1 part of concentrated nitric forms a solution (*aqua regia*) capable of dissolving gold and platinum. This solution is also used for etching on iron and steel, the craftsman having previously covered with wax those parts which are not required to be decorated. This acid produces a vapour at normal room temperature, as it reacts with water in the atmosphere to form a mist. Hydrochloric acid should not be stored near ammonia since the vaporized acid and the ammonia combine to form ammonium chloride, a white vapour which settles as a white layer on everything in the vicinity.

Bases

The classic test for bases is their ability to turn red litmus paper blue. In metalwork, bases are commonly used for cleaning. After grinding an object, ammonia is added to the pickle in order to dissolve grease and other impurities. If the object is very dirty, better results are obtained from using caustic soda or caustic potash.

Ammonia (NH_3)

Ammonia is a gas with the odour of smelling salts. It is a colourless anhydride which reacts as an alkali, turning red litmus paper blue. It is usually stored as a solution of ammonia gas in water. For cleaning purposes, a low percentage of ammonia is added to warm water already containing a synthetic washing powder.

Caustic soda (NaOH)

This is a strong water-soluble substance suitable for removing grease, particularly from silver objects before enamelling. If there is to be an overlay of transparent enamel it is important to provide a smooth metal base, since this part will remain visible. Working with opaque enamel, the smoothness of the base is less important. Caustic soda is corrosive, and it should be stored in a clearly labelled vessel with a good stopper, safely out of reach of children.

Caustic potash (KOH)

Potash is used in pickling solutions for removing grease and for general cleaning. The chemically pure substance is sold in flakes, in pieces, or as thin rods packed in tightly closed glass jars or soldered metal packings.

Other chemicals

Borax ($Na_2B_4O_7 10H_2O$)

Borax is used in flux preparations for hard soldering work, but it is also quite capable of serving as a flux by itself — borax powder is mixed into a paste which is applied to the joint to keep it free from oxide. Natural borax has been found in some lakes in California,

and Tuscany borax is produced in great quantities by neutralizing boric acid with soda. Borax, on heating, melts to a glass-like mixture which dissolves most metal oxides.

Boric acid (H_3BO_3)

Boric acid is available as a raw product, chemically pure or technically pure, or refined. The latter is the most common form, and refined boric acid is sold as flakes or as powder. Refined boric acid contains at least 99% pure boric acid, the remaining 1% consisting of insoluble sulphates, chlorides and moisture. Goldsmiths use boric acid mixed with red spirits when soldering on gold; this mixture is applied to the polished surface after immersion, so that the surface will retain its shine and its freedom from oxides.

Pumice stone

Pumice stone is a light grey, porous, fairly hard lava; in a pulverized state it is used for grinding metal surfaces where a brighter shade is desired after colouring or oxidation. Powdered pumice stone, mixed to a thick paste with water, is applied to metal surfaces either by rubbing or with a brush, until a satisfactory result is achieved. The most commonly used pumice powder is 6/0 quality.

Enamelling glue

Enamelling glue is a tough, colourless, odourless, transparent, rubber-like substance obtained from the trunk of a shrub called Stragulus. If immersed in water it swells to a sticky grey substance which is very suitable as enamelling glue. To make this mixture, take 1 small level teaspoonful of this pulverized substance and mix with $1\frac{1}{2}$ decilitres ($\frac{1}{4}$ pint) of warm distilled water. The mixture should be well stirred until the powder has dissolved completely. When ready, it should possess a smooth-flowing consistency. This mixture can be bought as gum tragacanth, and cellulose wallpaper paste is also very good if used in a thin solution.

Wax

Beeswax is a good lubricant when working with wire and when sawing. It is used in etching as a protective layer on the metal surface, the acid then only touching the pattern outlined through the wax layer. Other useful acid resists are shellac, or self-adhesive plastics material, such as Fablon, cut to shape.

Acetone (CH_3COCH_3)

Acetone is a well-known solvent used for dissolving resin, fats, oils, rubber, and even cellulose varnish. In the manufacture of highly polished copper objects, the surface can be brushed with Ercalene lacquer to inhibit oxidation; the lacquer can later be removed with acetone. Acetone is also capable of removing the thin layer of ordinary nail varnish sometimes applied to the inside of bracelets made of non-precious metals.

Hallmarks

The Worshipful Company of Goldsmiths in London give the British legal standards for gold and silver in their *Memorandum on the Law relating to Manufacture and Sale of Gold and Silver Wares*.

Briefly, the authorized standards of fineness are as follows:

Gold: 22, 18, 14 and 9 carats of fine gold in every pound weight troy (0.9166, 0.750, 0.585 and 0.375 respectively).

Silver: 11 oz. 10 dwt., and 11 oz. 2 dwt. of fine silver in every pound weight troy (0.9584 — Britannia silver — and 0.925 — sterling silver, respectively).

In general, British law requires that any gold or silver ware made in the United Kingdom or imported and sold shall be one of the authorized standards and shall be hallmarked before sale. There are some permitted exceptions — these may be delicate filigree or wire jewellery, and pieces to be set with stones which might be damaged by hallmarking.

The article to be hallmarked is submitted in a complete but unfinished state to the Hall with which the maker is registered. The assay is carried out on samples (called the diet) scraped from the workpiece, which is returned after testing. Should the article not comply with the legal requirements it is defaced or broken and returned in that state.

In Great Britain the silver hallmark consists of the maker's mark (which is registered); the assay mark (which for sterling silver is a Lion Passant); the assay office mark; and the date letter representing the year of marking, which changes every May.

The marks of the various Halls are as follows:

London: A Leopard's Head, full face
Birmingham: An Anchor
Sheffield: A Crown
Edinburgh: An Heraldic Castle
Dublin: A Harp

The gold marks are simply its carat rating and decimal equivalent.

In the U.S.A., the law requires only the maker's registered trade mark and a quality mark (e.g. 14K) to be put on articles for sale, and this is the responsibility of the maker. He does not have to send in articles for official assay.

Carat gold and carat weight

We are here dealing with two different meanings: for example '18 carat' refers to the quantity of pure gold in a gold alloy, pure gold being 24 carats. But 'carat' is also used as the weight unit applied to precious stones — these are metric carats. One metric carat equals 0.20 g., and 1 g. equals 5 carats.

The weight of pearls is expressed in grains. One grain is 0·05 g.

Care of jewellery

Some transparent precious stones lose their lustre if they are always in contact with grease. Opals are very susceptible, and should always be treated with great respect.

Washing jewellery

Jewellery should be cleaned from time to time in a liquid made up of 10 parts water and 1 part ammonia, with a little detergent added. The water should not be too hot. A soft nailbrush or toothbrush should be used to reach under the stones. Use tepid water for rinsing, and leave the jewellery to dry on a soft cloth.

If the setting of the stones is closed (in other words if they are not visible from below), do not immerse the piece in water. Damp sometimes penetrates beneath a stone and causes discolouring and loss of lustre. Clean it instead with a brush dipped in water. Less expensive costume jewellery should not be cleaned with liquid, but be brushed clean with a paste made from pulverized chalk mixed with water.

Cleaning silver

Silver darkens because it readily forms silver sulphide when exposed to the atmosphere. Perspiration, soap and cosmetics may also cause some discoloration. Clean silver with a proprietary polish, and do not let it get too black because it will be much more difficult to clean.

Suppliers

Great Britain	United States

Great Britain

United States

Metal
Silver
Johnson, Matthey & Co. Ltd.,
78 Hatton Garden,
London EC1P 1AE

Hoover & Strong,
111 Tupper St.,
Buffalo 1,
New York

Copper
J. Smith & Sons,
42-54 St. John's Square,
London EC1

Most craft stores; industrial metal suppliers listed in telephone directories

Jewellers' tools and equipment
Charles Cooper,
12 Hatton Wall,
London EC1N 8JQ

Allcraft Tool and Supply Co.,
Park Avenue,
Hicksville,
N.Y. 11801

E. Gray & Sons Ltd.,
12-16 Clerkenwell Rd.,
London EC1M 5PL

Anchor Tool and Supply Co. Inc.,
12 John St.,
New York,
N.Y. 10007

Enamelling equipment
Crafts Unlimited,
21 Macklin St.,
London WC2

Allcraft Tool and Supply Co.

American Art Clay Co.,
4717 W.16th St.,
Indianapolis,
Ind. 46222

W. G. Ball,
Anchor Rd.,
Stoke on Trent,
ST3 1JW

Kraft Corner,
5842 Mayfield Rd.,
Mayland Annex,
Cleveland,
Ohio 44124

W. J. Hutton (Enamels) Ltd.,
285 Icknield St.,
Birmingham 18

Thomson & Joseph Ltd.,
46 Watling St.,
Radlett,
Herts.

Western Ceramics Supply Co.,
1601 Howard St.,
San Francisco,
Calif. 94103

Wengers Ltd.,
Etruria,
Stoke on Trent,
Staffs.

Thomas C. Thompson,
1539 Deerfield Rd.,
Highland Park,
Illinois

Findings
Findings are available from most craft shops and jewellers' suppliers in Great Britain.

Allcraft Tool and Supply Co.

Anchor Tool and Supply Co., Inc.

Adhesives, abrasives, and non-specialised equipment are available at hardware stores in both Great Britain and the U.S.A.

Index